Contents

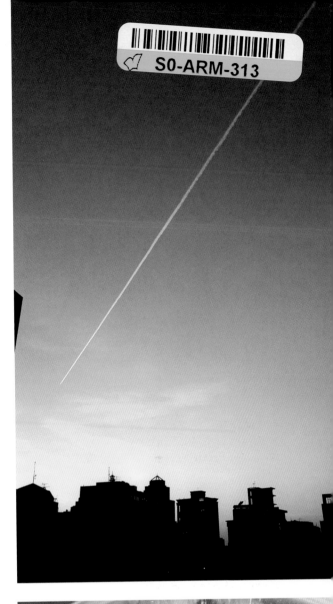

SO-ARM-313

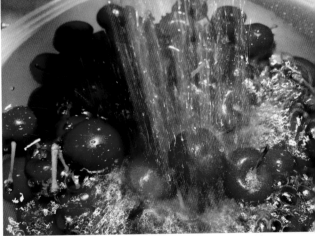

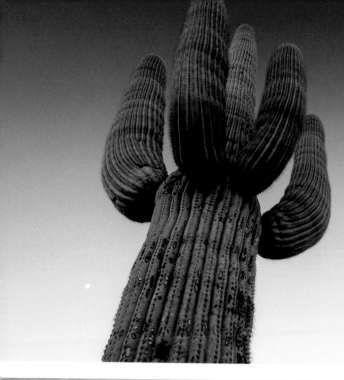

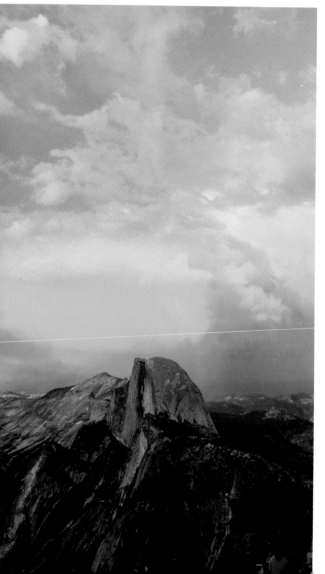

PHOTOGRAPH BY ROSIE ISRAEL.

About the Author

Mark Chen is a photographer, a digital media artist, and an activist. Based on still images and videos, he expands to media including animations, soundscapes, installations, and performances. The narratives in his work aim to raise awareness of sustainability and climate change, among other environmental and social issues. Chen's exhibition path traverses locally, nationally, and internationally, including the Houston Center for Photography, Fotofest (Houston), the Arc Gallery (San Francisco), and the Artists' Cabin (Taipei, Taiwan).

In addition to his career as an artist, Chen is an educator who has taught at the University of Houston, Houston Baptist University, and Houston Community College, among other institutions. He is also an avid published author, producing seven book titles on photographic art and techniques from Amherst Media. These titles include *Creative Wedding Album Design with Adobe Photoshop, Flash and Ambient Lighting for Digital Wedding Photography, Unleashing the RAW Power of Adobe Camera Raw, Professional HDR Photography, Mastering Exposure,* and *Mastering Composition for Photographers.* To learn more about Mark Chen, visit www.markchenphotography.com.

A Billion Photos Every Day

A billion photos are taken every day. That means that in the time it took you to read the last sentence, over 10,000 photos were snatched—and, presumably, most of them were taken on cell phone cameras. They are selfies, food images, pet photos, sunset images, and shots to document car accidents. They are taken at the Great Wall of China, on the way to work, and in bathrooms. They are shared on Instagram, Twitter, Facebook, and more.

> **Are these photos destined only to be posted on social media, liked a dozen times, and then forgotten forever?**

While these photos seem to serve lots of purposes and go lots of places, there is one thing they mostly do not do: make money.

Is the new cell phone–toting generation hopelessly locked in a spiral of mass consumption, without any productivity? Are these photos destined only to be posted on social media, liked a dozen times, and then forgotten forever? Are they just taking up space on your micro SD card, doomed to be erased when more selfies demand to be squeezed into the limited memory?

If you are one of the few exceptions who wants to break the mold, this book provides you with a powerful answer: stock photography.

What Is Stock Photography?

In a nutshell, stock photography is literally photos in an inventory. Contrary to photos produced for assignments (say, for a wedding, for a new building, or to showcase a specific

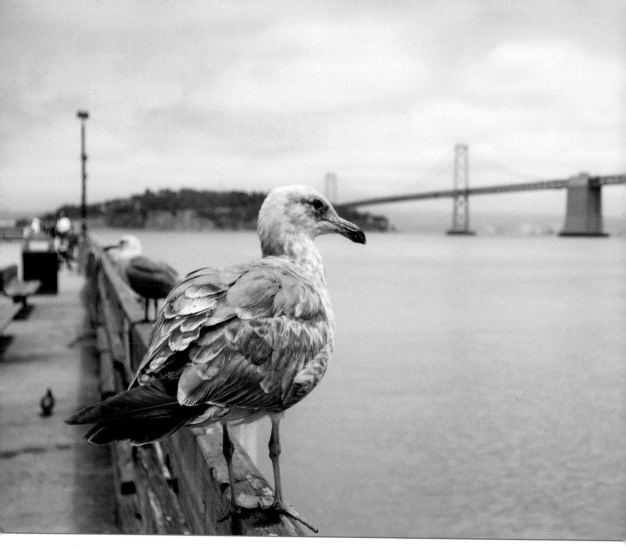

product, etc.) these photos are made by photographers who presume their usefulness to someone who might later buy them. For example, the photographer might think, "If I take an image of that light beam coming down from the clouds, churches might use it as an image to show spiritual inspiration." Likewise, an image of a nice bowl of salad might be used to promote healthy eating, or a headshot of a pretty girl might be a good image to promote a dating web site. These images are then put together in a database, ready to be searched by their potential buyers.

Who Sells Stock Photography?

You can sell stock photography yourself, through your own web site. However, in this age of mass information shared in a global marketplace called the Internet, it is unlikely that your web site could attract as much attention as the site of a stock photography agency—a one-stop shopping site where buyers can find cataloged images by thousands of photographers. iStock, Shutterstock, Getty Images, and Fotolia are examples of stock photography agencies. The process for getting on-board at one of these

Image P–1. KEYWORDS: Bay Area; Bay Bridge; beak; claw; feather; gull; Laridae; San Francisco; San Francisco Bay; seagull; wing. *(More on keywords in chapter 2)*

agencies ranges widely. For some, you simply sign up. Some require a review of sample images. Others are by invitation only.

Who Buys Stock Photography?

Stock photography is used by advertising agencies, bloggers, churches, students, and everyone else in the world who needs to use photos in any medium of presentation—magazines, posters, web sites, PowerPoint projections, etc. Whether or not they are a trained professional, the person who searches for the stock photo is considered a graphic designer.

What is graphic design? The *Merriam-Webster Dictionary* defines it as "the art or profession of using design elements (as typog-

▶ ALL TECH CONSIDERED

Amazing Cameras

Cell phone cameras have come a long way since the days of Nokias and Ericssons. Apple's iPhone and Samsung's Galaxy series produce images that easily beat point-and-shoot cameras—even if the camera model is just a few years old.

The amazement is doubled when we consider that the cell phone camera is just one aspect of the function offered by these hand-held devices, which are literally small computers. And—oh, yes—they do make phone calls, too. The compactness is required, but it also comes with a price. The lens and the sensors have to be very, very small. These characteristics affect how we use cell phone cameras and how we can bring out the best in them. In other words, there is some skill required to use the camera in its sweet spot.

raphy and images) to convey information or create an effect; also: a product of this art." Imagine that a graphic designer is charged to design something. This process often requires the use of one or more images. Assuming she does not have this image, and that producing it would not be feasible (or efficient, or cost-effective), that's when she turns to a stock photo agency. She provides the agency the criteria for the image and that information is used to determine a list of candidates. She sees an ideal image among all the candidates, pays the agency, and obtains a right to use that image.

As a stock photographer, you should pay close attention to graphic design and designers. Knowing how projects are designed (and how designers think) is essential for success.

> " As a stock photographer, you should pay close attention to graphic design and designers. "

How Do Stock Photographers Get Paid?

Each agency has its own pay schedule designed to give the contributing photographer their cut of the money from each image sale.

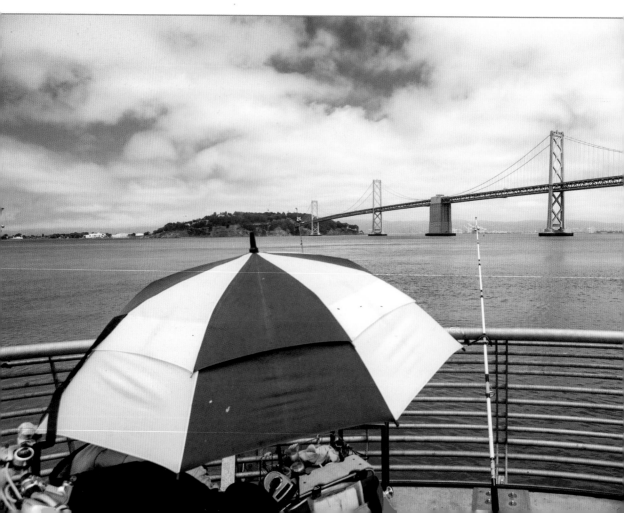

This is one of the first advantages of stock photography as a profession: the pay is residual. If money has inertia, most of the income in the world has *low* inertia. When you start working, the pay starts to flow; when you stop working, the pay stops. Stock photography, on the other hand, does not start paying immediately when a rookie starts to shoot and upload images. It picks up the pace gradually and the pay starts to pour in as the photographer continues to expand her presence in the stock photo world and more graphic designers choose her work for their projects.

This kind of income has high inertia. It might feel like a drag at the beginning, but its true advantage kicks in when you want to slow down or take a break—because the money's momentum is maintained by this inertia. The stock photos continue to sell and the photographer continues to get paid, even when he is attending to his other business or relaxing on a cruise ship (where he might be taking some more great stock images to be uploaded when he is back on land).

Stock photography can be a career, a side job, or a hobby. The money it generates can range from the major source of household income, to a secondary income, to pocket money that barely covers the cost of a cell phone. It all depends on the quality of your images and the effort you put into it.

Image P-2 (above). KEYWORDS: Battery Park; boat; cloud; ferry; New York; sky; Statue of Liberty; tourism. *(More on keywords in chapter 2)*

Image P-3 (left). KEYWORDS: Bay Area; Bay Bridge; bicycle; bike; fence; fish; fishing; leisure; San Francisco; San Francisco Bay; sports; umbrella. *(More on keywords in chapter 2)*

1. Do Cell Phones Really Work for Stock Photography?

Today's cell phones capture fabulous photos that work well in many graphic design projects. The era of the cell-phone stock photo officially dawned when iStock started accepting cell-phone images in 2012. Alamy, an agency that performs stringent image inspection, rescinded its ban on cell phone captures in 2014. The same year, Fotolia announced a $5,000 prize for the best iPhone image. Stock photo agencies are notorious for rejecting images they deem not up to par with their quality-control standards. So their change of mind on cell-phone photos speaks volumes.

Can Cell Phones Compete with DSLRs?

Let's be clear: cell phones are not going to replace professional, high-tech DSLRs. However, cell phones are improving and the images are now rivaling those produced by

> " The era of the cell phone stock photo officially dawned when iStock started accepting cell phone images in 2012. "

▶ ALL TECH CONSIDERED

The Lens

Samsung's S5 and Apple's iPhone 6 have multi-element lenses (meaning they feature an assembly of several lens components) with a 4.8mm focal length and an f/2.2 aperture. Samsung's S6 jacked it up to f/1.9. Seasoned DSLR users should not be misled by these numbers, though. A focal length of 4.8mm sounds very, very short—but when put on a tiny sensor (only 4.8mm long), the field of view (FOV) appears to be the equivalent of a 35mm lens on a full-frame sensor. That's a very comfortable FOV for general photography. Likewise, apertures of f/2.2 or f/1.9 imply very shallow depth of field (DOF) on a full-frame DSLR. But with the exceptionally short focal length, the DOF is actually, again, quite comfortable. It is important to note that the apertures on cell phone cameras are fixed.

DSLRs . . . well, 10-year-old DSLRs. In reality, cell phones will never take over because standalone digital cameras lead the way in technological innovation and development. That cutting-edge technology only trickles down to cell phones several years later. There is no way the tiny lens and sensor, only part of the functionality of a incredibly compact electronic device, can outperform contemporary DSLRs, with bulky lenses and bodies that are made to perform just one function: taking photos.

All that said, we can turn some of the supposed "limitations" of the cell camera to our advantage and use the device to create great-looking, salable images. And, in fact, we'll find that cell phone cameras actually do beat out DSLRs in a few ways. Let's look at a few of those upsides.

▶ ALL TECH CONSIDERED

The Shutter

To control the duration of the exposure (the shutter speed), cell phone cameras use either mechanical or electronic shutters. Like its focusing mechanism, the mechanical shutter in Samsung's Galaxy series is built with microelectromechanical technology (MEMS). This shutter has 36 tiny bimetallic leaves. These leaves curl and straighten when different voltages are applied, a motion caused by the different characteristics of the metals. These motions are used to open and close the shutter. Apple's iPhones, on the other hand, employ an electronic shutter. This switches the sensor itself on and off to achieve the exposure. From the impressive performance of cell phone cameras from both makers, we can conclude that both shutter styles are good solutions.

Ease of Use

First is the ease of use. A cell phone is literally a flat live-view screen. Shooting with a cell phone frees the photographer's face from the viewfinder and reduces the natural tendency to shoot at eye level. That alone can lead to more refreshing perspectives. Look around and see how a photographer can "dance" with her cell phone. This makes capturing images with a cell phone much more versatile and flexible than shooting with a DSLR.

66 The automatic features on cell phone cameras are now so robust. 99

Automatic Features

A second advantage of shooting with a cell phone is that the automatic features on cell phone cameras are now so robust.

The camera usually sets the ISO and shutter speed (again, the aperture is not adjustable on cell phone cameras) in a very smart, accurate manner. When occasions arise for which the settings need to be customized, there are also camera apps that allow you to shoot with manual settings.

Shooting Through Obstructions

Another minor advantage of shooting with a cell phone is the small lens opening. Unlike bulky DLSR lenses, this

> ▶ ALL TECH CONSIDERED
>
> ### Auto Exposure
>
> Analyzing hundreds of shots made on a Samsung with its native camera app in the auto exposure setting, I have concluded that it is programmed to use the lowest ISO possible, balancing the exposure by adjusting the shutter speed within a $1/15$ to $1/6400$ second range. Only under low-light conditions, when the shutter speed dropped to the slowest possible setting, did the ISO start to increase beyond 640. In moderate lighting conditions, it favors $1/30$ second, while keeping the ISO as low as possible. As the light increases, it drops the ISO to 40 before the shutter speed goes above $1/125$ second. At $1/125$ second and faster, it is all ISO 40.
>
> The auto exposure mode on an iPhone 6, similarly, keeps the ISO settings as low as possible. When the light is low, it favors a shutter speed of $1/30$ second and starts to increase ISO from its minimum of 32 only when the shutter speed drops below $1/30$ second. Unlike Samsung's S5 which maintains the lowest shutter speed at $1/30$ second, the iPhone 6 allows shutter speeds to drop to $1/4$ second, which is not suitable for handheld shots; there is a substantial risk of motion blur. However, the iPhone's top shutter speed (thanks to its electronic shutter) is much faster than on the Samsung—it goes as fast as $1/20,000$ second!

> 66 From time to time, all photographers regret missing great images – simply because they didn't have a camera with them at the moment. 99

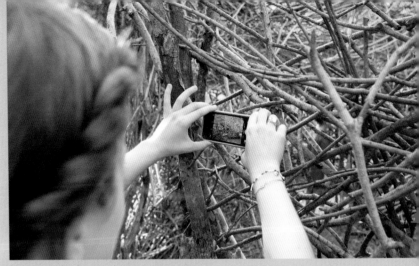

Image 1–1. A tiny cell phone lens can photograph through a jumble of twigs without being blocked.

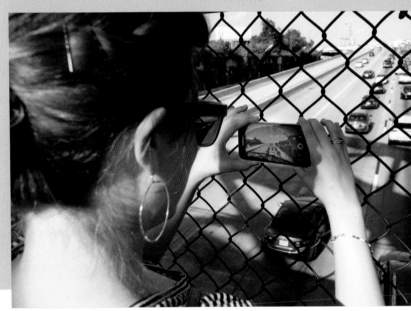

Image 1–2. Very often, the best views from a bridge are blocked by a wire fence. While a DLSR would fumble here, the fence is not a problem for a cell phone camera.

> 66 This is particularly helpful when photos need to be taken through a fence. 99

enables the cell phone camera to peek through a small hole without partially blocking the view. This is particularly helpful when photos need to be taken through a fence.

It's Always There

And the biggest advantage? Your cell phone is always there! Most cell phones owners are intimately attached to their devices and can instantly access them from their pockets, holsters, or purses. From time to time, all photographers regret missing great images—ones that might have made them rich and famous—simply because they didn't have a camera with them at the moment. No more excuses!

Great photo ops manifest themselves around us at unexpected moments. Out of nowhere, the reflection of the setting sun on an office building (one you stare at every day while waiting for the bus) transforms it into a glorious symbol of commerce—stop texting and start composing! The familiar neighborhood running trail is flourishing with toadstools today—snatch the shots while the music continues playing in your earbuds. Stuck in rush-hour traffic? Ask your carpool driver to open the moon roof and stick your cell phone out to photograph the endless line of cars with all their tail lights turned on. Somewhere, sometime, a graphic designer working on an article about corporate America, a blog about medicinal mushrooms, or a report on carbon emission from automobiles is going to take a serious look at these shots.

DSLR or Cell Phone Camera: The Rule of Thumb

Now that we know the roles that DSLRs and cell phone cameras play for a stock photographer, a general rule for their usage is naturally formed. If there is a plan for a project—that may involve recruiting models, scouting a location, and setting up props—there is no reason we should show up with a cell phone camera. Shooting that session with a DSLR is clearly the right choice. When we walk on the street, tour the museum, or drive home from work and sud-

> 66 Composition is to photography as grammar is to language. 99

▶ VISUAL GRAMMAR

What Is Composition?

Composition is to photography as grammar is to language. Grammar provides rules that help speakers, readers, and writers communicate more effectively. Using these rules, we can place words and phrases into sentences and feel secure that others will understand what we mean. Photographers use compositional elements in the same way—to assemble all the components of an image so it will convey a certain quality and evoke an anticipated reaction from the viewers.

Stock photography is special in that the image will then (hopefully!) be discovered by another artist and recomposed with additional elements in a secondary graphic project. That means our initial compositions have to communicate to a collaborator—one who happens to be, in most cases, a total stranger. To appeal to these artists/buyers, we need to compose our images with a particularly strong eye toward conveying a message. This does not mean we should play it safe and use only the conventional compositions. Graphic designers are like us—they have all kinds of tastes and all kinds of personalities!

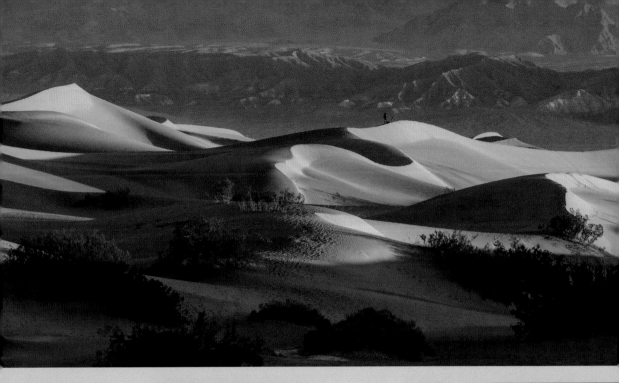

Image 1–3. KEY-WORDS: desert; sand; sand dune; dune; Death Valley; dawn; photographer; mountain, Nevada; national park; nature; park. *(More on keywords in chapter 2)*

Image 1–4. KEY-WORDS: bay; bubble; cloud; cruise; good weather; mountain; reflection; see; ship; sky; splash; spray; sunny; wake; wave. *(More on keywords in chapter 2)*

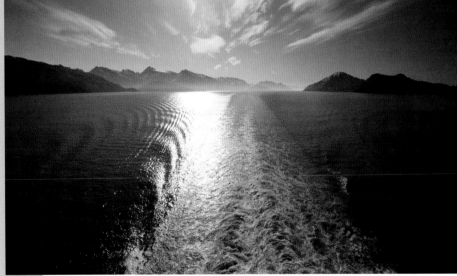

denly encounter a stunning photo op, a cell phone camera is there to save the day. Therefore, the examples you see this book do not represent the entire breadth and depth of stock photography. Instead, we're going to look at how cell-phone photography can fill in the gaps and enhance your overall catalog of stock images.

2. Keywording

Before we dive into the process of actually taking photographs to sell in the stock market, we need to take a quick side-step into the stock market itself. As we've learned already, the point of taking stock photographs is for graphic designers to find them, buy them, and use them in their projects. The way this happens is through the use of keywords that the photographer assigns to each image. When a designer enters search terms, looking for an image, these keywords will determine which images are returned in her search results.

These keywords are basically a collection of words or phrases that describe the content, aesthetics, and/or other criteria of the photo. Keywording in stock photography is arguably just as important as the photos themselves because the keywords are the faces of the stock images. Before the thumbnails of your stock photos can appear in a buyer's search results, he or she has to think of a collection of keywords that describe the desired photo(s) for the project. If you have managed to think of the same keywords, your images will be on the starting line and poised to win the race!

Not a Fun Task— But Absolutely Necessary

Making up keywords is not a glamorous task. It squeezes the brain juice, it keeps us at the computer, and it can be boring—if not downright frustrating. How we wish we could put an end to this as soon as possible, get the upload started, and get out there to start shooting again! Of course, then we'll just end up having to devise more keywords for the new images. There is no escape, my fellow stock photographers.

A Systematic Approach

After keywording thousands of stock images, I have devised a systematic approach that reduces the chances of overlooking keywords, increases the breadth and depth of the keyword collection, and (most importantly) expedites the process.

Identify the Top Attribution

Each worthy stock photo has its major attributions. It can be a specific place. For example, **image 2–1** is an aerial image of the Sydney harbor. What would be the top attribution here? "Sydney Opera House," of course. "Cruise ship" might be another key-

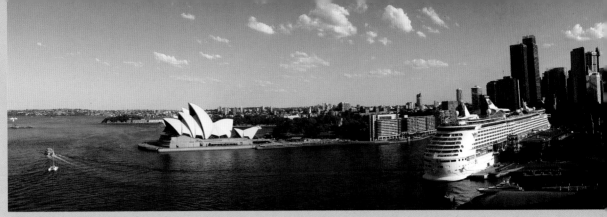

Image 2–1.

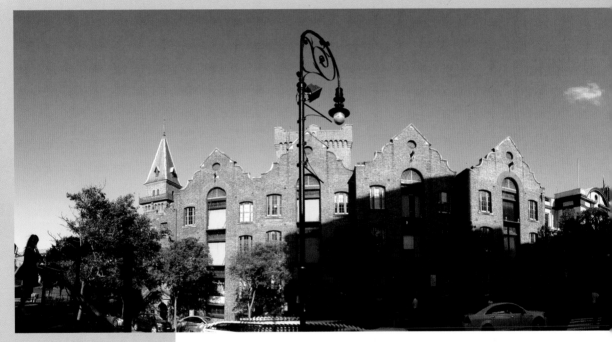

Image 2–2.

> **"One keyword can be more effective than another in a search."**

word you'd consider. Now consider **image 2–2**. This image was also taken in Sydney, but because of its lack of identifiable landmarks, the first keyword that comes to mind would not be Sydney. "Castle" would surface as the top keyword.

One keyword can be more effective than another in a search. Once both "Sydney Opera House" and "cruise ship" are both assigned to **image 2–1**, searching for either keyword can lead to a hit. However, the chance of it being picked during research on the Sydney Opera House is higher than it being picked in a "cruise ship" search, because the former term is much more specific.

It is possible that more than one attribution could be equally important. Consider **image 2–3**. Here, "Bay Bridge," "bike," and "San Francisco" are equally important keywords. A graphic designer could be thinking about the landmark, the trend of city biking, or the destination. This image can serve all three narratives, so its thumbnails should surface when a designer enters any of those search terms.

Do Your Research

Don't rush. Don't be lazy. Do the research. There is no point in saving a few minutes of time if it means sacrificing the potential sales of a stock photo. Let's look at an example. What is the name of the strange plant in **image 2–4**? It is not a straightforward task to find out. Searches on Google Images aren't good at identifying objects with similar shapes (they are best at identifying identical images). So how did I find out that this plant is called Karoo Rose? I posted it on Facebook and I asked around! A florist friend offered help. From Karoo Rose, I Googled its scientific name: Lapidaria margaretae. What is the fountain called in **image 2–5**? The landmark of Chicago? Using Google Maps, it was not hard to find out that the name is Buckingham Fountain.

> ❝ There is no point in saving a few minutes of time if it means sacrificing the potential sales of a stock photo. ❞

These are very specific keywords—and it's highly possible that they might be the only ones a buyer would use when starting a search. If you skip them, the image might never see the light of day.

Image 2–3.

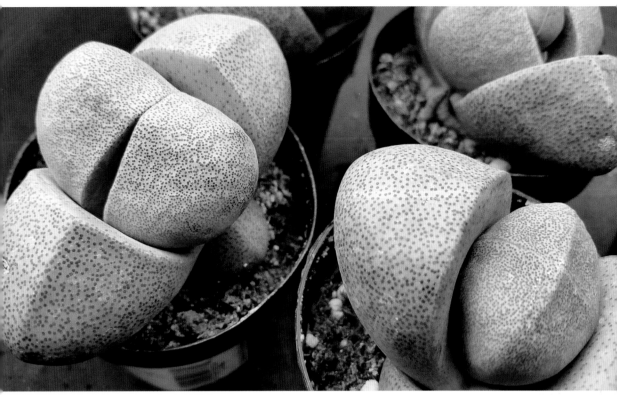

Image 2–4.

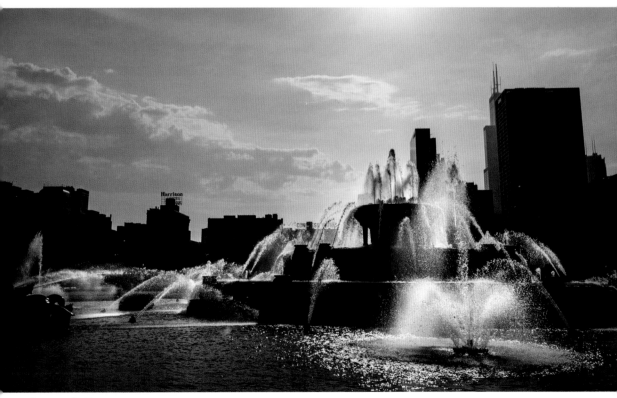

Image 2–5.

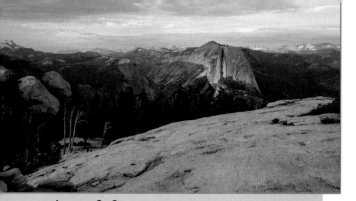

Image 2–6.

Work from the Specific to the Generic

Let's use **image 2–7** as an example. To analyze the specificities of the keywords, I will use tiers. Tier 1 would be the most specific. As the number increases, the keywords become more general.

> Tier 1: Half Dome, Trinity Point
> *[where the photo was shot]*
> Tier 2: Yosemite
> Tier 3: national park, California
> Tier 4: dusk, sunset, glacier, hike, tree, rock, valley, geology, mountain
> Tier 5: nature, outdoors

My approach is to start by typing the tier 1 keywords. Then, I think about what would encompass that term. For example, "Yosemite" would be a generalization of "Half Dome." "National park" would be a generalization of "Yosemite." "Nature" would be a generalization of "national park." Higher-tier keywords should never be neglected; omitting the lower-tier ones, on the other hand, does not constitute a catastrophic error.

❝ Tier 1 would be the most specific. As the number increases, the keywords become more general. ❞

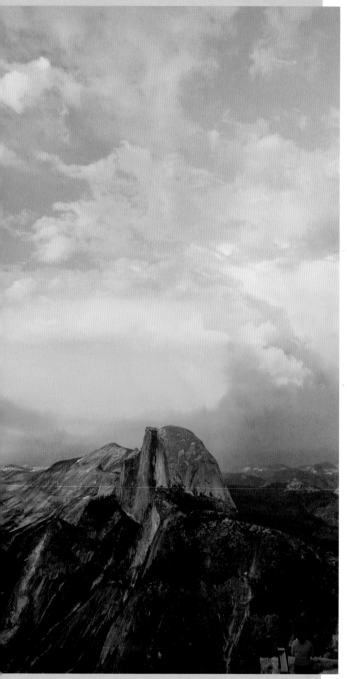

Image 2–7.

Use Keywords for People, Objects, Activities, and Conditions

Be sure to include keywords to describe these four categories of attributes, if they exist in the image. Let's consider **image 2–8**, for example.

People:	woman, Hispanic, female, biker, cyclist
Object:	bike, bicycle, bike route, bridge, helmet, guardrail
Activity:	biking, cycling, workout, exercise
Condition:	healthy, fit, fitness, sunny

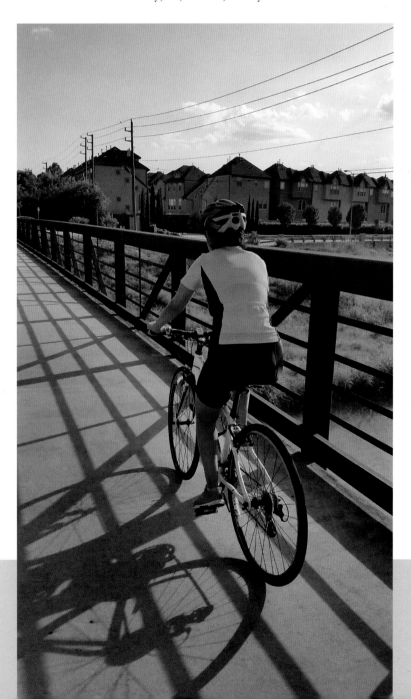

Image 2–8.

State the Obvious and the Implied

When stock photo buyers search for images, they sometimes think of a very specific object—for example, a wind turbine. However, they might not have that specificity in mind; a term like "renewable energy" might come to mind first. As a result, images of solar panels, wind turbines, and/or hydraulic generators can all show up, giving the image buyer a range of options.

Consider **image 2–9**. If we ignore the surrounding objects and focus on the wind turbine, we can come up with keywords, ranging from the obvious to the implied:

Obvious: wind turbine, wind farm, blade, nacelle, generator, tower *[parts of a wind turbine]*
Less Obvious: wind power, power generation, renewable energy, green energy
Implied: environment, environmental protection, environmentally friendly, carbon emission
Very Implied: climate change, global warming, rising sea level

Do keep in mind that the stock photo agency can reject keywords. The chance of rejection is higher at the "implied" end of the scale. It is highly likely, though, that a buyer using a keyword such as "environment" would be interested in an image of wind turbines. So put them out there; rejection is a fact of life for a stock photographer. Be at peace with rejection and do not self-censor for it.

In This Book

To help you get a hang for keywording images, I've included keywords for most of the photos in this book. Keep an eye on them in the captions as we move forward and talk about how to shoot cell phone stock images.

Image 2–9.

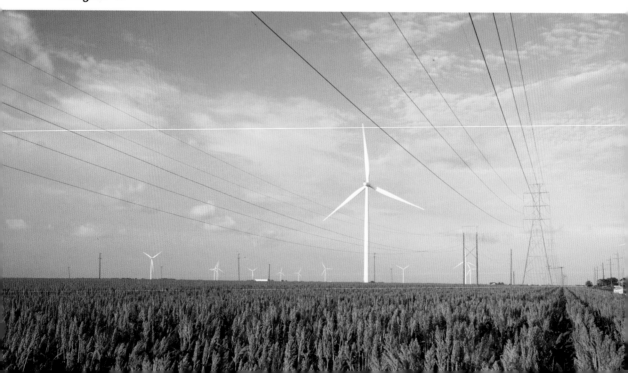

3. Travel

As we established in the previous chapter, DSLRs should be part of the plan for sessions that are set up in advance. Cell phones are best for spontaneous images—see a great shot, pull out your phone, and capture that great shot. This can be very useful when we are traveling and our senses are heightened by all the new sights. When traveling, photographers tend to be more sensitive and more observant. We need that cell phone camera when inspiration calls!

Landmarks (or Not)

A photograph is not limited to serve as evidence that "I have been to _____ (any tourist spot of the world)." In fact, sometimes an image that does *not* reveal its geographical location can be a better stock photo. Take **images 3–1** and **3–2**, for example. These shots from a cruise ship feature stunning views and an open composition with plenty of negative space. The fact that they were taken in Alaska is not important; these shots could be from a North Sea cruise, an Iceland cruise, or a cruise to Cape Horn.

On the other hand, **image 3–3** (next page) has a clearly identifiable landmark: the Statue of Liberty. Because it pinpoints an exact geo-

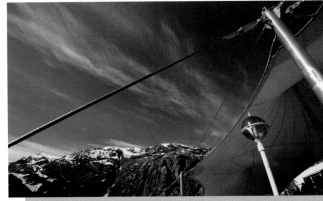

Image 3–1. KEYWORDS: Alaska; blue; cable; canopy; climate; cloud; cruise; cruiseship; glacier; Glacier Bay; mountain; National Park; peak; pole; sky; sunny; tension; tour; weather

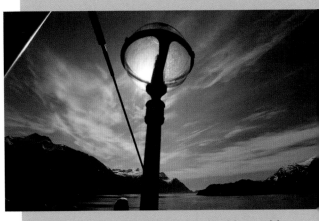

Image 3–2. KEYWORDS: Alaska; blue; cable; climate; cloud; cruise; cruiseship; glacier; Glacier Bay; lamp; light; mountain; National Park; passenger; peak; pole; sky; sunny; tension; tour; weather

graphical location, the keywords should reflect that feature. The uniqueness of this image, though, lies in the very wide field of view and very small subject. The fun psychology is that the smallness of the Statue of Liberty does not make it any less prominent; the viewer can identify it at a glance. The stunning seascape around it makes a great space for adding graphic design elements. This image appeals to the graphic designer on many fronts.

Images 3–4 through **3–10** were all taken in Chicago. The "identifiability" of these images falls in between the previous examples. None of the buildings or structures shown have the exalted status of the Statue of Liberty. However, people with an interest in architecture might be able to spot the John Hancock tower, the Navy Pier, Trump Tower, etc. These images can be used to showcase Chicago—or they could simply be used as generic city scenes.

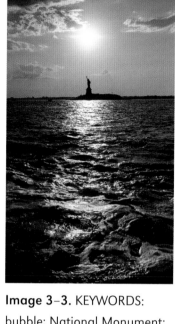

Image 3–3. KEYWORDS: bubble; National Monument; New York; see; Staten Island Ferry; Statue of Liberty; Statue of Liberty Island; sunset; wave

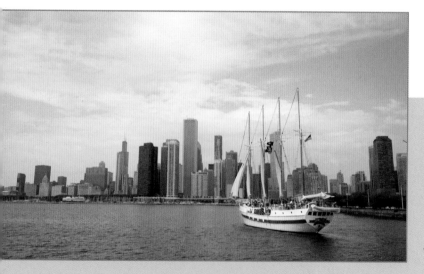

Image 3–4. KEYWORDS: Chicago; city; cloud; Lake Michigan; pier; pirate; sail boat; sky; skyline; skyscraper; tall ship; tour

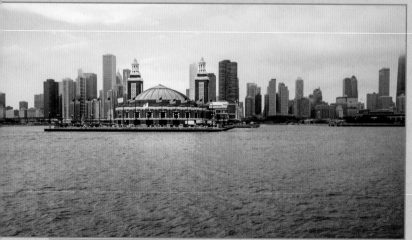

Image 3–5. KEYWORDS: architecture; building; Chicago; Chicago Children's Museum; city; dome; John Hancock; lake; Lake Michigan; lake shore; Navy Pier; Sears Tower; skyline; The Great Lakes

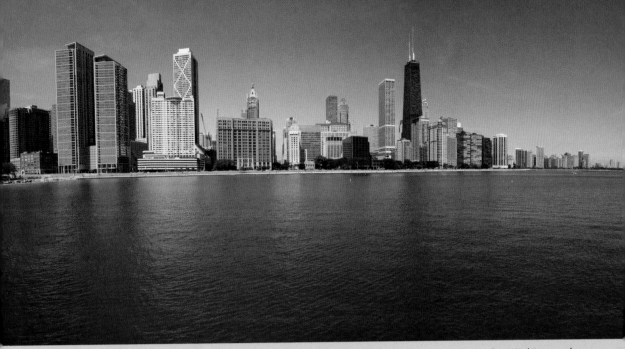

Image 3-6. KEYWORDS: architecture; Chicago; city; Illinois; John Hancock; lake; Lake Michigan; sky; skyline; sunny; water

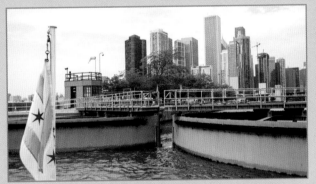

Image 3-7. KEYWORDS: Chicago; Chicago River; drinking water; flag; freshwater; reverse; river flow; skyline; water gate

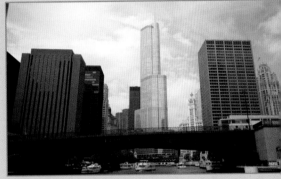

Image 3-8. KEYWORDS: boat; bridge; Chicago; city; cloud; Equitable Building; pier; sky; skyline; skyscraper; tour; Tribune Tower; Trump Tower

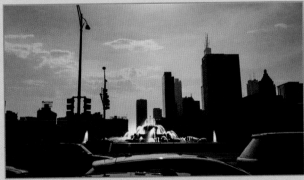

Image 3-9. KEYWORDS: backlit; Buckingham Fountain; cars; Chicago; city; CNA Center; fountain; Lake Shore Drive; Sears Tower; traffic; urban; Willis Tower

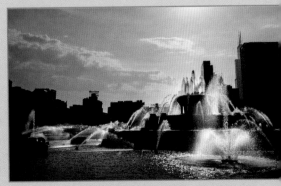

Image 3-10. KEYWORDS: backlit; Buckingham Fountain; Chicago; city; CNA Center; fountain; Sears Tower; urban; Willis Tower

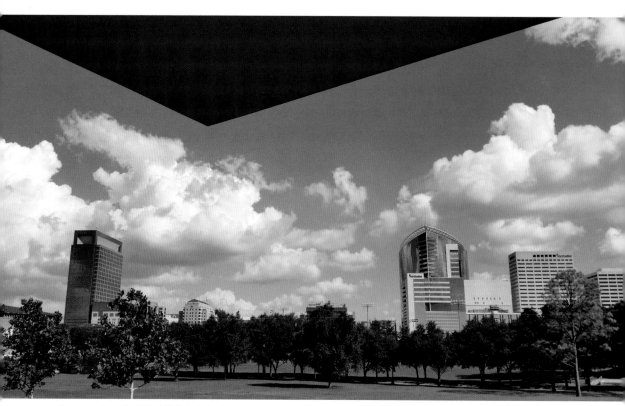

Image 3–11. KEYWORDS: building; campus; canopy; city; grass; Houston; medical center; Rice University; trees; urban

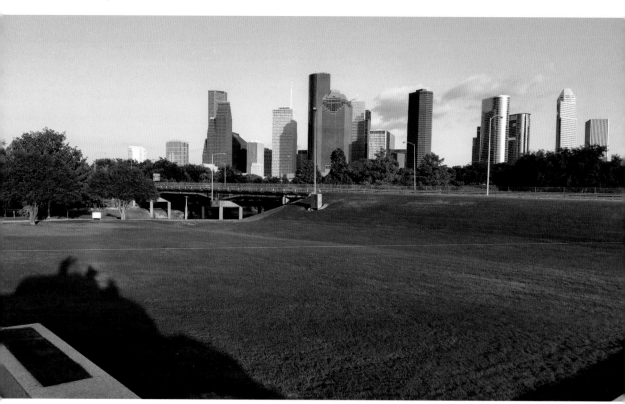

Image 3–12. KEYWORDS: architecture; building; Eron; grass; Heritage Plaza; Houston; Police Memorial; Shell; skyline; skyscraper; Wells Fargo

The Position of the Horizon

The position of the horizon is very influential in terms of the emotional impact a landscape image will have on viewers. Take images 3–11 and 3–12, for example. Both images portray Houston's skyline, but in image 3–11, the low horizon opens up the sky and creates a sense of the smallness of human activity. In image 3–12, on the other hand, the placement of the horizon emphasizes Houston's vast landscape. What we do here on Earth is the emphasis in this image.

" Lots of billboards in Houston feature images of its skyline. "

Images from less readily recognized cities like Houston (featured in images 3–11 and 3–12) are understandably often used as generic cityscapes. However, do not overlook the local buyers; lots of billboards in Houston feature images of its skyline. There aren't many buyers with this need, but there also aren't all that many Houston skyline stock photos available for sale—certainly not anything comparable to the number of images designers can choose from for New York City or Paris. The supply and demand are quite balanced in the world of stock photography. There can actually be advantages to obscurity; photos of a small town might not get hundreds of searches, but when someone *does* look for that town, they might have only a handful of thumbnails to choose from—giving each image a much higher chance of being purchased.

Cell Phone vs. DSLR

Let's talk some more about the difference between a cell phone camera and a DSLR. DSLRs are designed without the same size and weight restrictions as cell phones. This means DSLRs have larger pixels, bigger lenses, and processors that can churn lots of data. Cell phones are the opposite; many more functions have to be contained in a much smaller space.

To compensate for this hardware limitation, the native camera app is designed to find the hardware's sweet spot. So, use the original app, use it in auto mode, and use the HDR mode to maximize the dynamic range. I don't suggest using apps that try to turn the cell phone camera into a DSLR; manually setting a cell phone camera is like trying to fly a drone after deactivating the GPS, gyro, and other high-tech wonders. At that point, you're just a 20th century dude misusing a 21st century gadget.

Remember: cell phone cameras don't have adjustable apertures, so there is no control over depth of field. A cell phone camera is a totally different animal from a DSLR, so don't try to use it as one.

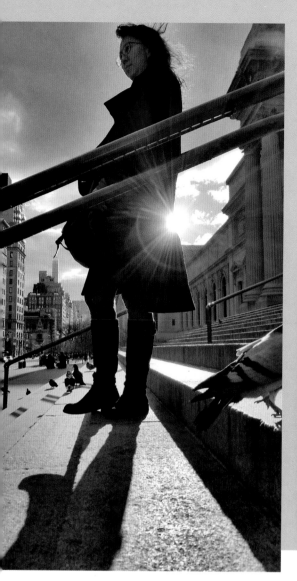

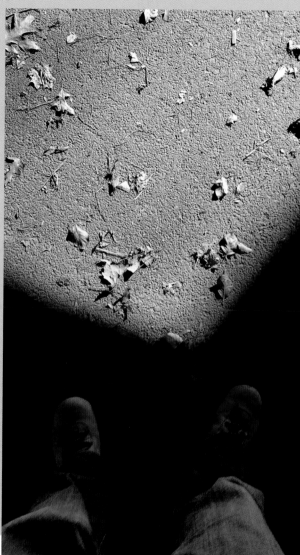

Cell Phone vs. DSLR Subjects

Images 3–13 through **3–16** were shot in New York City. Clearly, I did not focus on prominent landmarks in these images taken with my cell phone camera. I planned my trips to those spots and shot them with my DSLR. My cell phone captures at those moments served mostly for the purpose of GPS tagging or Facebook posting. These four images, however, are good examples of impromptu shots—taking advantage of great photo ops that just appeared out of the blue, when my DSLR was out of reach. When it happens, pull out your cell phone!

Image 3–13 (left).
KEYWORDS: 5th Avenue; Metropolitan Museum; New York; New York City; pedestrian; pigeon; shadow; stair; sun; woman

Image 3–14 (right).
KEYWORDS: boots; fallen leaf; feet; jeans; leaf; leaves; light; pavement; shadow; shoes

Image 3–15 (top). KEY-
WORDS: Central Park; city
park; New York City; park;
skyline; sunrise; sunset; trees;
urban park

Image 3–16 (bottom).
KEYWORDS: Central Park;
city park; New York City; park;
skyline; sunrise; sunset; trees;
urban park

▶ VISUAL GRAMMAR

Open vs. Closed Compositions

These two composition types are differentiated by their
use of negative (open) space. Closed compositions have
negative space at the margins; open ones do not. **Image
3–15** has a closed composition that provides a good over-
view of this stunning sunset in New York City's Central
Park. **Image 3–16** features an open composition, which
puts more attention on the intricate shapes of the trees
and the skyline of lower Manhattan.

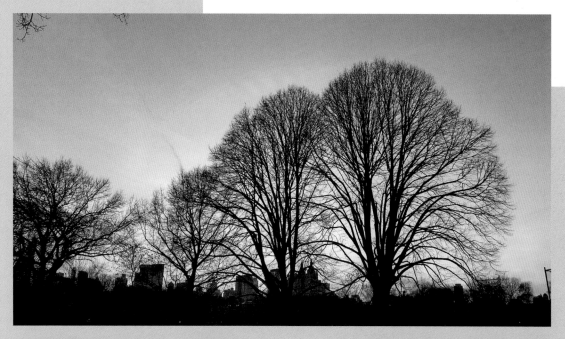

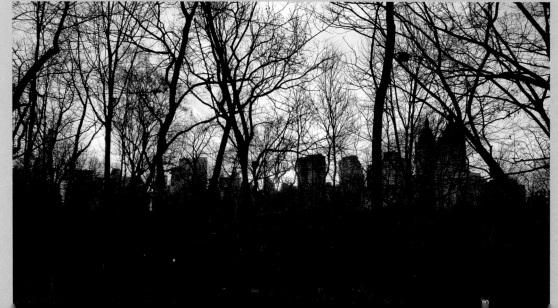

An Environmental Theme

The severe California drought during 2015 prompted me to start another environmentally themed project. During the shoots, which were done mostly using a DSLR to capture both still photos and video, I also noticed opportunities to shoot stock photos. **Images 3–17** through **3–20** were captured in such situations. Note that **image 3–17** and **image 3–20** both feature the DSLR camera. These will make them unique; with a serious-looking camera on a tripod pointing at the scene, the senses of observation and involvement are blended in with the content. Although this character can't be effectively expressed in keywords (we can use "observation," but buyers are not likely to search this way; using "camera" might work a little better), buyers who see the thumbnail would grasp that concept.

▶ VISUAL GRAMMAR
Negative Space

Negative space is not always the big sky. Consider **image 3–17**, an image depicting the California Aqueduct cutting through a drought-stricken grassland. A straightforward pick for negative space would be the large area of the grassland to the left.

66 Buyers who see the thumbnail would grasp that concept. 99

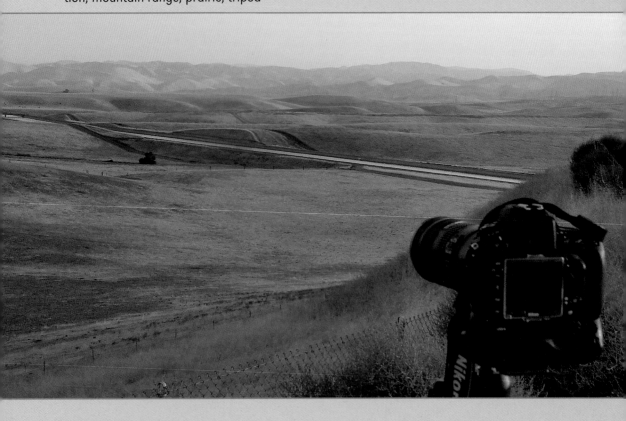

3–17. KEYWORDS: agriculture; California; aqueduct; camera; drought; dry; fence; grass; irrigation; mountain range; prairie; tripod

Image 3–18 (left). KEYWORDS: boat ramp; drought; lake; Lake Shasta; mountain; reservoir; water shortage

Image 3–19 (below). KEYWORDS: boot; drought; dry; feet; hike; hiking; leg; nature; pine cone; sock; soil

Image 3–20 (bottom). KEYWORDS: brush fire; California; camera; drought; fence; fire; fire hazard; grass; haze; prairie; smoke; sun; sunset; tripod; wire

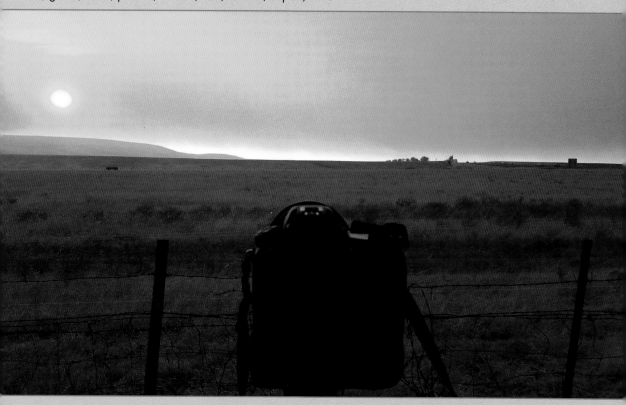

Including People

Images **3-21** through **3-24** were shot on a trip to Sydney, Australia. Here we have a wide range of identifiability—from **image 3-21**, which is likely only identifiable by the locals to **image 3-22**, an almost postcard-style image to which I applied a twist with the panoramic format. **Image 3-23** is a very interesting example. Besides the prominent appearance of the Sydney Opera House and the cruise ship (the logo, by the way, must be retouched out or it will definitely face the fate of rejection), the silhouettes of the cafe patrons set an interesting stage, making it more narrative. Another great thing about these silhouettes is that I might be spared the need for model releases, which are required in stock photography for "recognizable faces." Of course, the possibility of rejection for the requirement of a model release would depend on which inspector checked the image!

Image 3-21. KEYWORDS: Australia; castle; historic building; old town; panorama; souther hemisphere; street light; Sydney; The Rocks

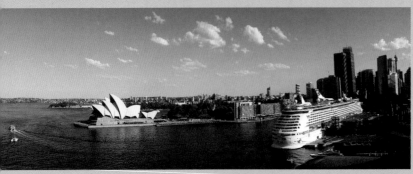

Image 3-22. KEYWORDS: Australia; boat; cruise ship; Harbor Bridge; ship; Sydney; Sydney Harbor; skyline; southern hemisphere; yacht

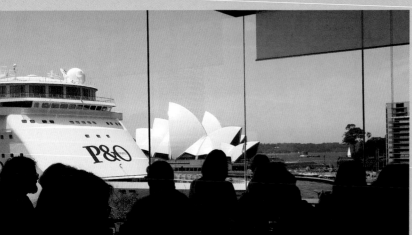

Image 3-23. KEYWORDS: backlit; cafe; cruise ship; customer; patron; restaurant; shadow; ship; Sydney; Sydney Opera House; silhouette

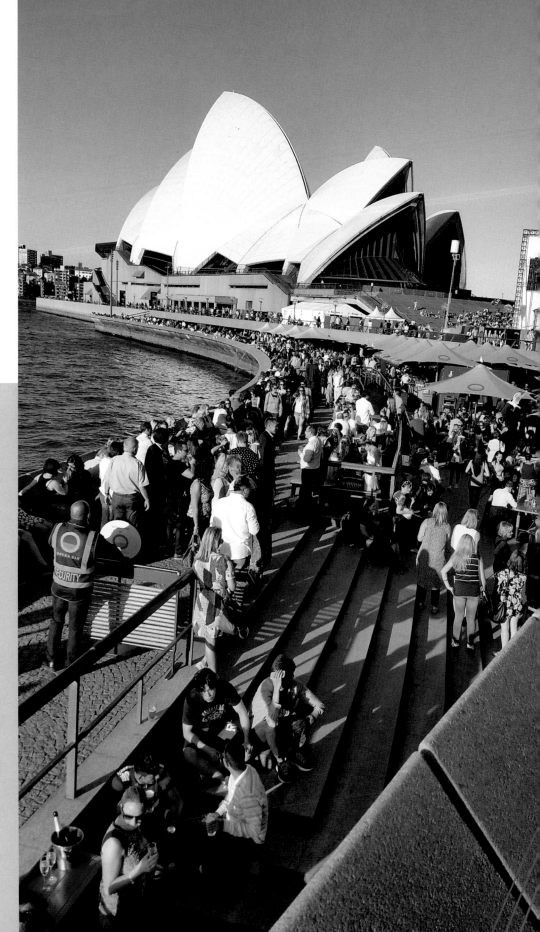

Image 3–24. KEYWORDS: architecture; building; crowd; outdoor; outdoor concert; people; Sydney; Sydney Harbor; Sydney Opera House; stairs

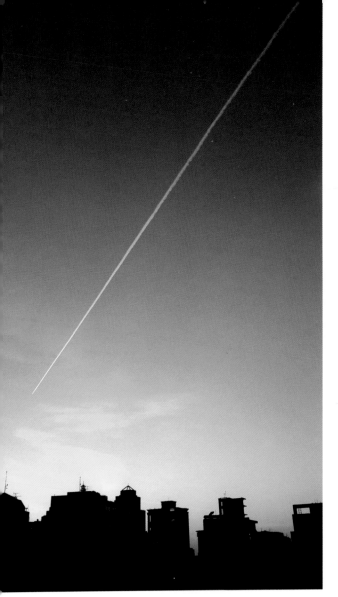

Image 3-25. KEYWORDS: airplane; building; city; cloud; flight; jet trail; sky; skyline; sunset; Taipei; twilight

A Fleeting Moment

Image 3-25 shows a glowing jet trail that appeared above a Taipei neighborhood. This breathtaking sight lasted for only about 30 seconds before the trail was blown away and the twilight lost its strength. What did I rely on to capture it? There was no better option than the cell phone in my pocket.

▶ ALL TECH CONSIDERED

How Cell Phone Cameras Focus

Gone are the days when cell phone cameras were "focus free." In those days, the strategy was to use the very deep depth of field (resulting from a very small aperture) to encompass a reasonable range of distances. The hope was for everything to look sharp; the reality was that nothing actually looked very sharp. Additionally, the very small aperture also made it very hard to capture decent photos under anything other than bright daylight.

Starting with the iPhone 4, AF (autofocus) became the standard. Thanks to a microelectromechanical system (or MEMS actuator) that replaced the traditional technology of a voice coil motor, the moving parts of the AF system were made much smaller—so small that they could be contained within the tight confines of a cell phone. (To see a MEMS actuator in action, watch this video: https://www. youtube.com/watch?v=5YxoyHzGYzw)

Like the autofocus on a DSLR camera, the cell phone camera's focusing system is based on a closed loop of feedback between the focusing mechanism and the sensor. The sensor reads the scene and feeds that information back to the AF; the AF system then continues to move until the sensor detects a sharp image. You might not hear the whirring, but when you tap on the screen to focus, some tiny element in the cell phone is working hard for you.

4. Food

Food photography, once a special field in photography, has become everyone's pursuit—so much so that it is now a cliché. When waiters bring dishes to the table, the first reaction of many diners is not to dig in but to reach for their cell phone to grab a food photo. I think it is safe to say that stock photo shoppers don't find it hard to search for a photo of any particular dish. So, why don't we provide food-related images that are more special? Adding a twist to our food photography is the goal. But how? Let me show you with the examples in this chapter.

A Rustic Twist

For **image 4–1,** I photographed plums soaking in an interestingly scratched container. This was resting on the kitchen counter, lit by gentle afternoon sunlight though the window. The backlighting and unusual vessel made it too good a still life to skip.

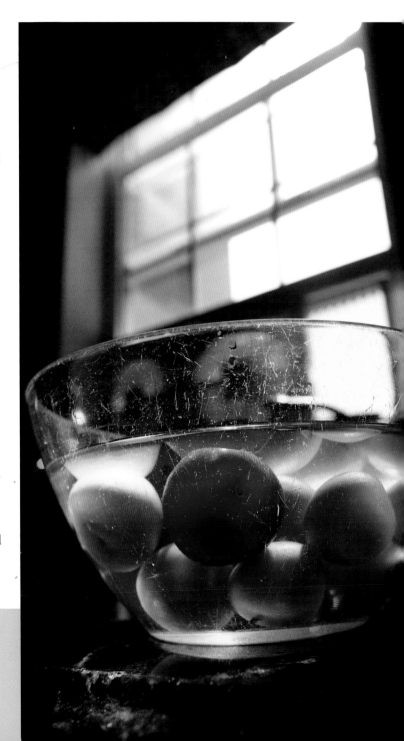

Image 4–1. KEYWORDS: bowl; clean; counter; fruit; kitchen; plum; red; soak; wash; water; window; yellow

Image 4–2. KEYWORDS: farmer's market; food; market; plant; root; turnip; vegetable; veggie

Image 4–3. KEYWORDS: beet; beetroot; carrot; farmer's market; food; market; plant; root; vegetable; veggie

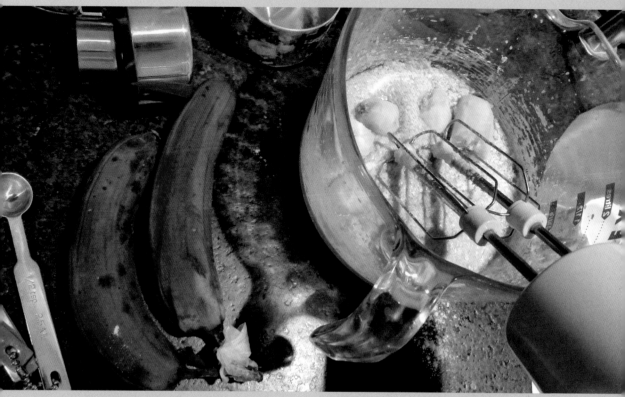

Image 4–4. KEYWORDS: baking; banana; black banana; counter top; flour; glass; granite; measuring cup; measuring spoon; mixer; ripen; ripe banana

Images **4–2** and **4–3** are two images from a farmer's market. The displays of this traditional market format are nostalgic and provincial, a sight that is less familiar to busy urban dwellers. The repetition of the veggies makes these images heavy on the compositional elements and texture, highly compatible aesthetics for a graphic designer's consideration.

Behind the Scenes

How about images from behind the scenes? **Images 4–4** (above) through **4–6** (next page) show scenes from making banana bread. Showing the blackened banana, the cooking accessories, the whipping of the batter, and the bread freshly from the oven (with a beautiful crack), these images would be great for a recipe web site. With your cell phone, you can shoot these even when your hands are covered in flour. Cell phones, after all, are not as delicate as DSLRs.

> “ With your cell phone, you can shoot these even when your hands are covered in flour. ”

Image 4–5. KEYWORDS: baking; blend; blender; cake; container; cookie; cooking; egg; flour; mix; mixer; motion blur; rotate; sugar; turn; whip

Turn That Flash Off!

There is nothing uglier than a photo lit with direct flash. The smallness of the flash on a cell phone and the closeness to the lens are the culprits. Unlike some flashes for a DSLR that have a rotating head to implement bouncing techniques that soften the light, cell phones' flashes can't change directions.

Image 4–7.

Look at **image 4–6**. If I had left the decision to the cell phone, it would have used the flash and turned it into something like **image 4–7**. What a nightmare!

Go to your camera settings (use the manual if you need to), find the entry for flash, and learn how to set it to OFF. (However, if you see an alien getting off a flying saucer in the pitch dark, forget this rule—turn the flash on and grab a shot that *Time* will buy from you for $10,000!)

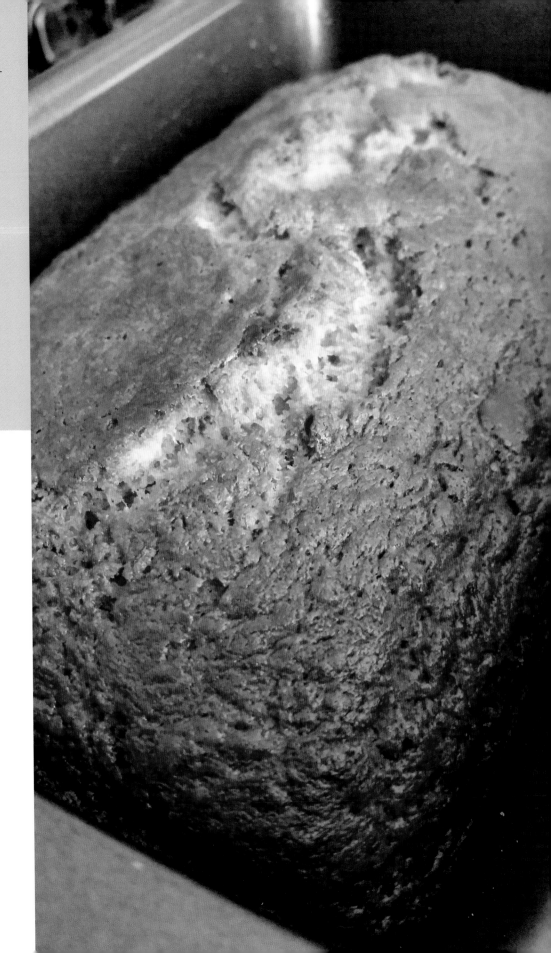

Image 4–6. KEY-WORDS: baking; banana bread; banana cake; banana walnut bread; banana walnut cake; mold

The same idea is presented in **images 4–8** and **4–9**, where close-up images of the finished product (bread) and one of the ingredients (grated cheese) occupy the whole frame in an open composition. The open composition did not just simplify the images by excluding distractions, it also emphasized the textures of the food, triggering the viewer's imagination to fill in the missing senses of smell and taste.

Image 4–8 (right). KEYWORDS: bake; bakery; baking; bread; flour; oven; recipe

Image 4–9 (below). KEYWORDS: cheese; dairy; grated; Italian; milk; parmesan; Parmigiano-Reggiano; shredded

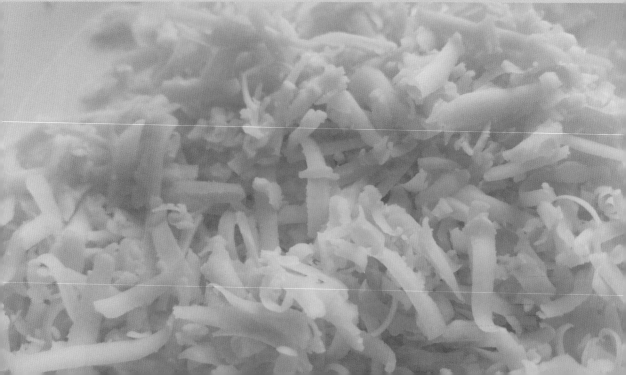

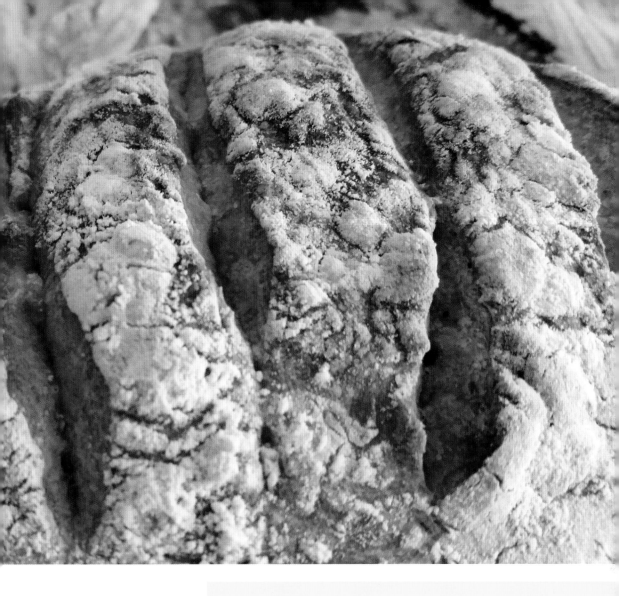

66 Successful food photography has everything to do with the viewer's imagination. 99

Texture

We love the taste of food and we love food photography. A well-done food photo makes our mouths water! Has the irony of this ever occurred to you, since we can't taste the food in a photo? Successful food photography has everything to do with the viewer's imagination, and the key to exciting this imagination is capturing the texture. Our senses are intertwined. Our happy memories of delicious food are related to visuals—like the glaze over a fruit tart, the slightly burnt surface of a steak, or the light shining through a glass of full-bodied red wine. If the textures of these visuals are depicted in the photo, we can taste the food by looking at it. **Image 4–8**, showing a fresh-from-the-oven loaf of bread, has this quality.

Light—Lots of Light

Samsung and Apple cram many pixels into their phones' tiny sensors by using very high pixel densities. While the resolution boost is nice, it comes at a price. High pixel density means small pixels—1.12 microns on the Samsung S5 and 1.2 micron on the iPhone 6. These are tiny compared to the pixels on DSLR's sensor—4.8 microns on the Nikon D810A and 4.14 microns on the Canon 5D. Small pixels result in lower signal-to-noise ratio, which means more image-degrading noise.

Noise thrives in low light and at high ISO settings. A combination of both is a recipe for disaster. Knowing this shortcoming of your cell phone camera, it is best to use it under plenty of light. **Image 4–12** (page 46) is a good example of this. This collection of food ingredients was placed under a rather strong spotlight—nothing fancy, just a 15-watt LED (which equates to an 80-watt incandescent)—that is pointing at the sink to ensure no grease is spared while washing pots.

If you think that cell phone shots you made under low light look just fine, look closer. Open the images in Lightroom or Photoshop and zoom in. You will almost certainly find that noise is a real problem. Stock photo agencies are picky about the quality—and so are the graphic designers who buy images from them. So, use lots of light and go for the best quality images.

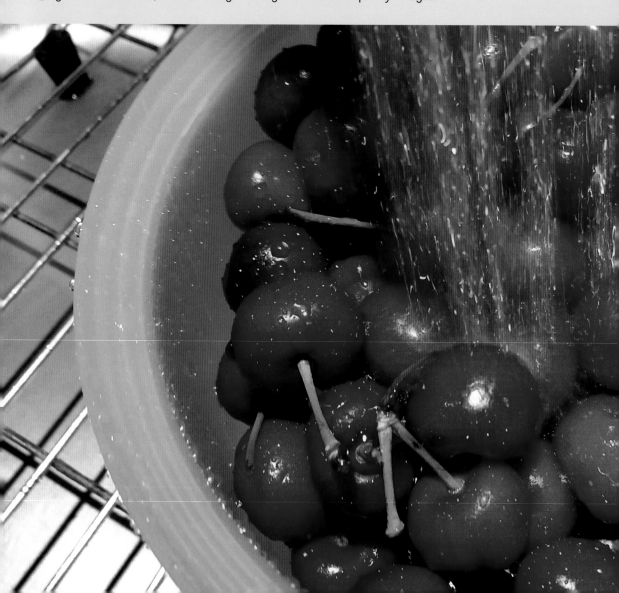

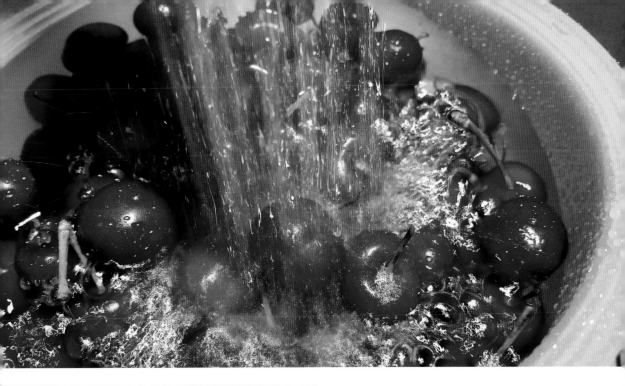

Food Handling

Washing cherries can be a brief moment of food preparation most photographers would neglect, but aesthetically it can be very pleasing. Look at the splashing water on the shiny, plump, and fully ripened cherries! Contextually, this is not just about food; it is also about safety in food handling.

Images 4–10 and 4–11 (left and above). KEYWORDS: bubble; cherry; container; contamination; drop; food handling; food safety; fruit; kitchen; plastic; rinse; running water; sanitary; sink; wash; washing; water

Image 4–12 (above). KEYWORDS: bamboo leaf; chestnut; Chinese food; dragon boat festival; Duanwu festival; dumpling; egg yolk; mushroom; rice; salty egg; shitake

Image 4–13 (left). KEYWORDS: bamboo leaf; Chinese; Chinese food; dragon boat festival; Duanwu festival; dumpling; rice; string; tie; wrap; wrapping

Exoticism

Exoticism is often a good approach to reach a niche market. **Images 4–12** and **4–13** depict two stages of making Chinese dumplings. First, the ingredients are laid out and prepared to be stuffed into the bamboo leaf. Then, the wrapping process begins. The ingredients were photographed in an open composition, for the purpose of simplifying and purifying the composition. I can't claim credit for the motion blur of the wrapping

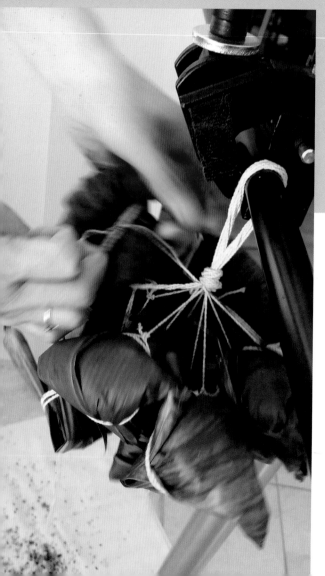

66 Cutting a bitter melon reveals its interesting profiles. 99

hands in **image 4–13**; the settings of a cell phone camera are really not something we want to dictate too closely.

Cutting a bitter melon reveals its interesting profiles, as shown in **images 4–14** and **4–15**. What would be better in the background than a wood cutting board and a knife? A wood cutting board is a far better choice than a plastic one because close examination will reveal its more intricate textures.

Image 4–14.
KEYWORDS:
balsam-pear;
bitter gourd;
bitter melon; bit-
ter squash; cut;
cutting board;
food; fruit; kitch-
en; kitchen knife;
knife; Momor-
dica charantia;
patrick; slice

Image 4–15.
KEYWORDS:
balsam-pear;
bitter gourd;
bitter melon; bit-
ter squash; cut;
cutting board;
food; fruit; kitch-
en; kitchen knife;
knife; Momor-
dica charantia;
patrick; slice

66 The foods are enticing and the patrons' enthusiasm draws us into the moment. 99

Re-Envisioning Restaurant Images

The last three images in this collection were, like most of the food photos on Instagram, taken in a restaurant. Still, there are twists to make them unique. In **image 4–16**, the composition of a glass of IPA next to a glass of pale ale, with an out-of-focus female patron in the background, entices our desire for a few sips of cold beer and sets a storytelling stage. It also avoids the necessity to obtain a model release from a total stranger. If the stock photography agency's inspector still deems the face recognizable, blur it more in Photoshop and resubmit. **Images 4–17** and **4–18** were photographed in a Chinese restaurant, using a similar compositional approach. The foods are enticing and the patrons' enthusiasm (out of focus so as not to overwhelm) draws us into the moment.

▶ VISUAL GRAMMAR
The Rule of Thirds

Imagine dropping a tic-tac-toe grid over your image. This divides the image into thirds both vertically and horizontally. There will also be four points where the lines intersect. These

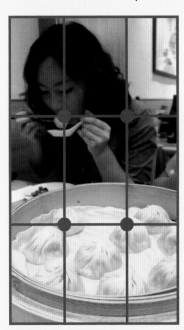

four points, according to this "rule," are the optimal positions to place the subject that you want viewers to concentrate on. **Image 4–18** is an example of such a composition (as diagrammed in **image 4–19**). The young diner's face is at one of the points. The buns occupy two of the other points.

Image 4–19.

Inside the Mind of a Graphic Designer
Interview with Evan O'Neal

Evan: I have been thinking about making fictitious magazine covers in crazy formats. This is a square format. *Delta* is the title of the magazine.

Mark: Written in the Greek alphabet? That is what you like to do, encoding text, isn't it?
Evan: Yes, indeed! The magazine is about art and travel.

Mark: When you are looking for photographic images to put into your design, what are you looking for?
Evan: I am looking for simple ways to make a point while making it interesting.

Mark: So, in the first design, you used the leaf image in the middle and the power lines with blue sky in the background. What did you see in them to make you use them this way?
Evan: Nature's gentle shape and colors have their healing power. The harsh artificial structure, on the other hand, is something most people would rather not look at.

Mark: So this is a contrast between something harsh and artificial and something gentle and organic?
Evan: Yes.

Mark: How about this cover with the blue sky behind dense tree branches and a panoramic view of the Grand Canyon?
Evan: In the image of the branches, it is so close and so personal—the dew water could drip on you. The Grand Canyon, on the other hand, is very far and wide.

> " I am looking for simple ways to make a point while making it interesting. "

Above–Sample design by Evan O'Neal. Left–Original images by Mark Chen.

Right–Sample design by Evan O'Neal. Below–Original images by Mark Chen.

△

Issue 3

Above–
Sample
design
by Evan
O'Neal.
Left–
Original
images
by Mark
Chen.

> 66 Be prepared for the designer to find totally different thoughts in that image. 99

Mark: From the designer's point of view, what is the thing you are looking for when you search for an image?
Evan: I am looking for an image that has a story behind it. A point of view. But the point of view might not be what the photographer had in mind.

Mark: That is a very interesting point! Does that mean a stock photographer does not have to think too much about their images?
Evan: They do have to think a lot—but be prepared for the designer to find totally different thoughts in that image.

Mark: In other words, we should not assume too much for the designer. We should not tell ourselves, "Oh, they are going to want this and that."
Evan: Exactly. But a photographer should still put a lot of his or her own thoughts into it. What makes an image stand out for my eyes is its storytelling.

Mark: This brought to me a very fundamental question. We tend to assume there is a standard "stock photo" look—bright sun, bright smile, bright everything. What is your take on that?
Evan: *[making a vomiting gesture]* Yeah, that is why sometimes I resort to illustrations instead of photographs—so I don't have to swim up a river of generic-looking images to find the image I can use. And I do spend hours a day looking for ideal images. There is also a fight between the client and the designer. The former tend to think about more generic images—smiley face, bright sunshine, etc. Sometimes they win, sometimes we win.

Mark: And you don't speak for all the designers either.
Evan: Actually I do. I was elected the designer of America, North America—just kidding! *[both laugh]*

5. The Wonders of Nature

Nature's wonders are all around us—if we look closely. Photographers are discoverers; we notice things that most people don't. When these common yet wondrous views are presented in our work, we photographers prove our value. Make this talent your asset. Use it in stock photos to boost the appeal of your portfolio.

Small Wonders

The wonder of nature comes in all sizes. The small ones, in particular, are easily ignored by the unobservant. The snails in **images 5–1** and **5–2** appeared on my back door after a night's rain—and they are perfect examples of the little wonders we can discover if we look closely enough.

Best of all, a cell phone is actually a great device for capturing images of them. With its very close focusing distance

> 66 Photographers are discoverers; we notice things that most people don't. 99

Image 5–1.

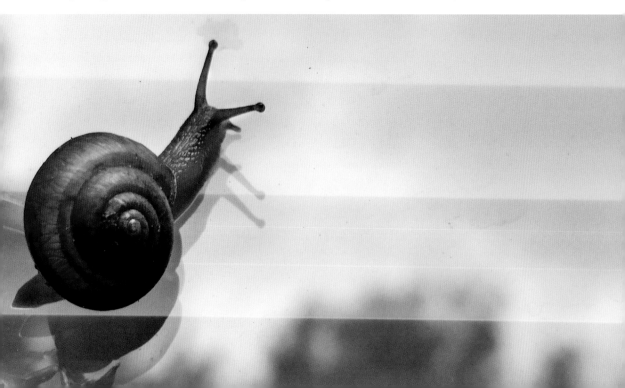

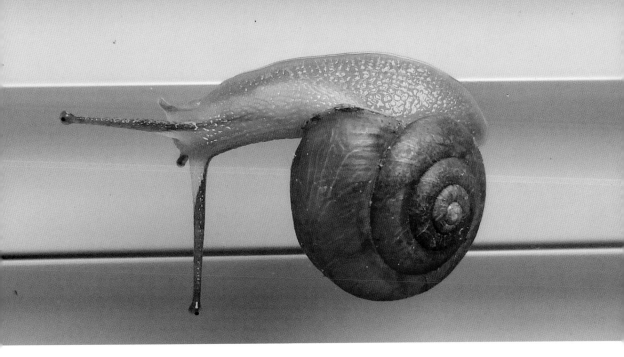

Image 5-2.

and tiny sensor, a cell phone can be a powerful tool for macrophotography—the photography of small objects. On my Samsung S5, a ½-inch snail can fill the frame. I closed the blinds to simplify the background, while still putting the creature in the context of the human domain. With close-range focusing, the depth of field is shallow, so make sure your hands are steady. Hold your breath when pressing the shutter and "shotgun" several images to ensure you have one that is sharp. It's better to have many images as candidates.

▶ VISUAL GRAMMAR

Open vs. Closed Compositions

Open and closed compositions differ in their use of negative (open) space. Closed compositions have negative space at the margins. For example, the snail in **image 5-2** is clearly having a solo show; it is shown completely and has a wide margin of negative space around it. This is a closed composition, which is more traditional and easy for designers to incorporate into their projects. On the other hand, **image 5-4** (next page) has a open composition. This close-up of the succulent emphasizes the repetitive pattern and the intricate details of the plant. Therefore, using an open composition not only reigned in the viewer's concentration, it also sidestepped the problem of how the background might fit into the composition.

Image 5–3 (top left). KEYWORDS: desert; desert plant; fat plant; gardening; garden; plant; succulent

Image 5–4 (top right). KEYWORDS: Crassulaceae; desert; desert plant; fat plant; gardening; garden; hen-and-biddies; hen-and-chickens; hens and chicks; plant; succulent

Image 5–5 (center left). KEYWORDS: lamb's ear; plant; Stachys byzantina; Stachys lanata; Stachys olympica

Image 5–6 (bottom left). KEYWORDS: calla lily; flowering plant; garden; herbaceous; plant; Zantedeschia elliottiana

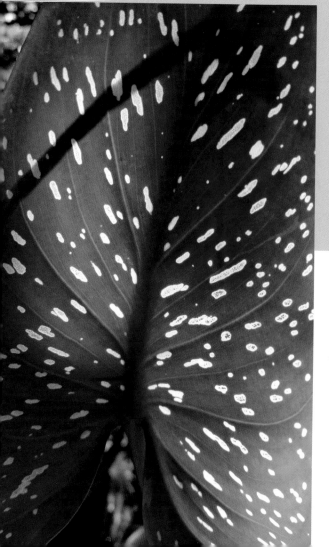

My sister's little garden has lots of fun-looking succulents and cacti. **Images 5–3** through **5–8** are some of the shots I took there. Getting closer is one simple tip for photographing these tiny flora. Once the whole plant, or a group of plants, fills the frame, they become universes of their own—with fine details and fascinating patterns.

Image 5–7. KEYWORDS: desert; desert plant; fat plant; gardening; garden; plant; succulent

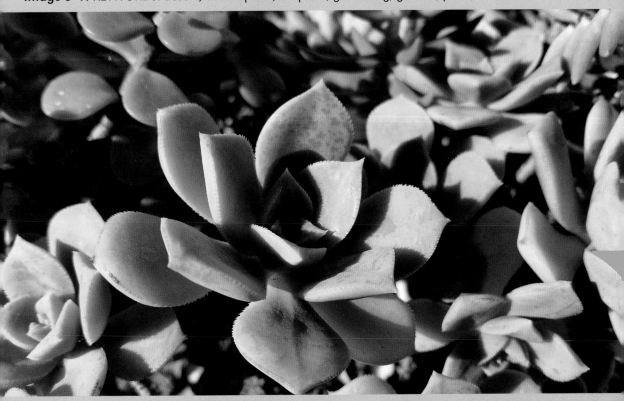

Image 5–8. KEYWORDS: desert; desert plant; dwarf succulent; fat plant; gardening; garden; Karoo rose; Lapidaria margaretae; plant

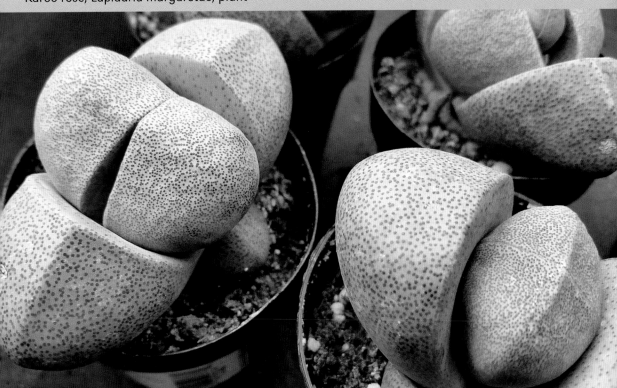

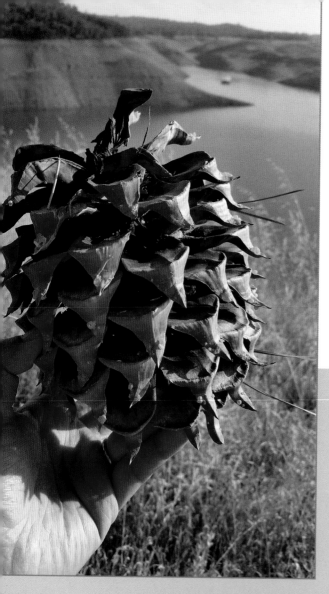

Curious Subjects

Images **5–9** and **5–10** are so different and so similar at the same time. Their similarity lies in the revelation of curious subjects; their difference lies in the capturing process. The image of the pine cone was a planned composition, whereas capturing the image of the bird trainer required a photographer's quick reflexes to act when a great composition presented itself for a brief moment. When you capture an image that shows a person's face, don't forget to approach them with a model release form in your hand—and ask nicely.

Image 5–9 (left). KEYWORDS: California drought; drought; dry; grass; hand; lake; pine cone; plant; reservoir; trees

Image 5–10 (below). KEYWORDS: animal trainer; beak; bird; bird of prey; eagle; falconry; glove; hawk; raptor; talon; trainer; wing; wingspan

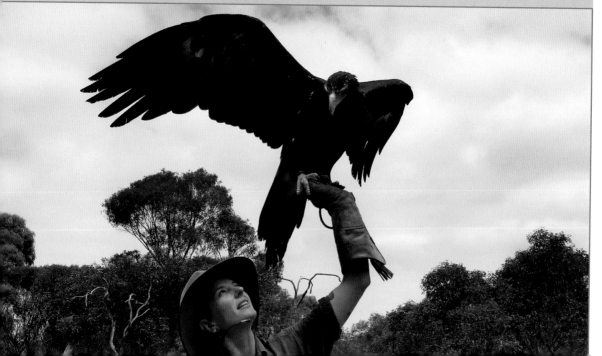

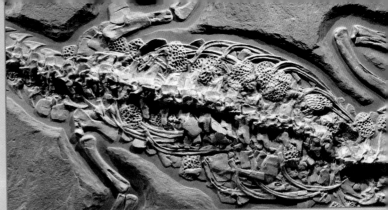

Image 5–11 (above). KEYWORDS: ancestor; bone; dolphin; fetus; fossil; Jurassic; paleontology; rib; spine; steneosaurus; stenopterygius quadriscissus; unborn

Image 5–12 (top right). KEY-WORDS: ancestor; bone; crocodile; fossil; paleontology; spine; steneo-saurus

Image 5–13 (right). KEYWORDS: arthropods; Devonian; exoskeleton; fossil; ordovician; paleontology; Redlichilda; trilobite

Fossils

Fossils of animals that died millions of years ago are fascinating. **Images 5–11** through **5–13** are a few examples that showcase the details. These close-up shots emphasize the skeletal structures of the trilobite, crocodile, and ancient dolphin.

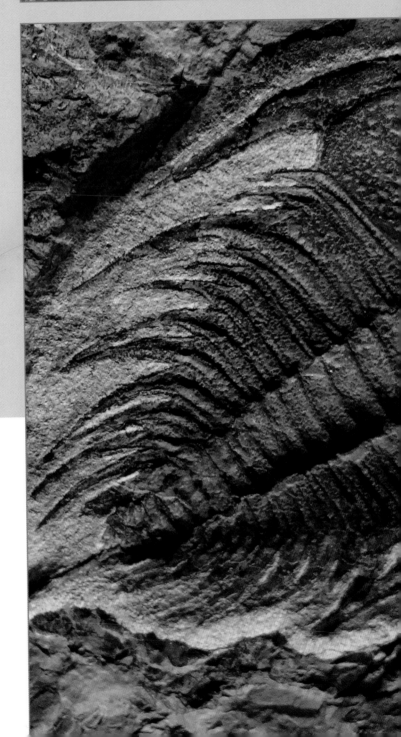

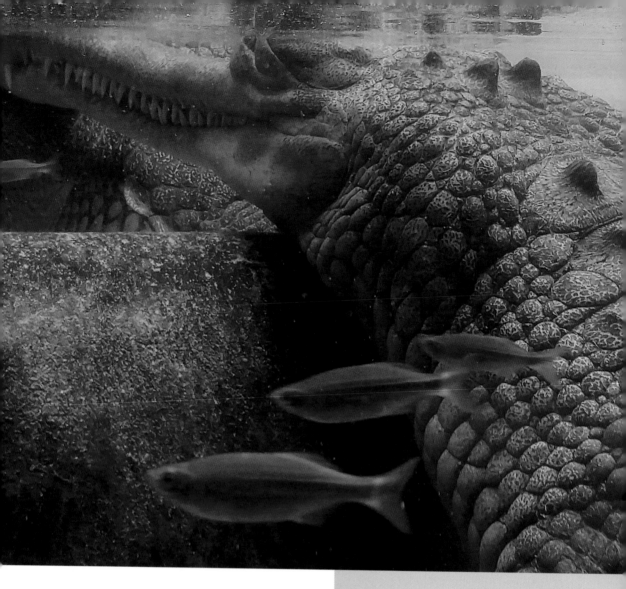

Zoos

Images at zoos are seldom satisfactory. The distance to the animal, the fence, the crowd, and the man-made structures are not our allies. **Images 5–14** and **5–15** reflect a rare opportunity I was able to capture with my cell phone. This alligator rested near a window and was lit by soft morning light, showing off the details of its scales and its streamlined body. The fish around it add depth and variety. Utilizing my Samsung S5's zoom feature, I provided two composition choices.

Image 5–14 (above). KEYWORDS: alligator; Alligatoridae; crocodilian; fish; Forth Worth Zoo; reptile; river; swamp; Texas; Texas alligator; zoo

Image 5–15 (right). KEYWORDS: alligator; Alligatoridae; crocodilian; fish; Forth Worth Zoo; reptile; river; swamp; Texas; Texas alligator; zoo

Help Your Cell Phone Camera to Focus

Both the Samsung S5 and iPhone 6 do good jobs of focusing. Both models allow the photographer to tap on an area of the screen to focus, too. This technique is called selective focus. Interestingly, it comes more naturally on a cell phone camera than on a DSLR—where you have to switch out of the default focusing mode and use either a four-way switch (Nikon) or a wheel (Canon) to designate the focusing point manually.

Thanks to the super-large live preview on cell phone cameras, and the way the camera is held, tapping a spot on the screen makes setting the selective focus an ergonomic, intuitive, and user-friendly operation. The super-large preview also enables you to photograph at ease from all angles.

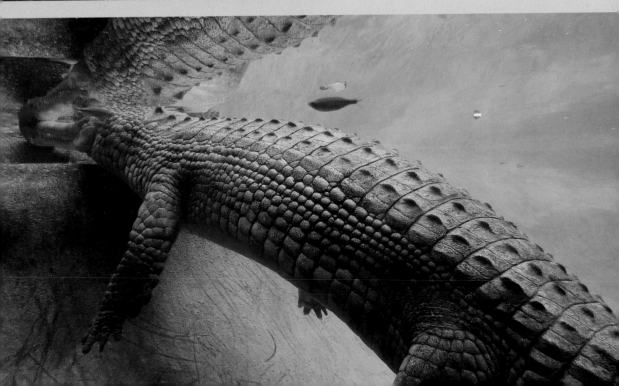

6. Environmental Change

The environment should be on everyone's mind. The United Nation's 2015 Climate Summit in Paris has finally brought the world to some consensus. With this development, the demand for images concerning the environment, climate change, energy sources, etc. is on the rise. Visually addressing these issues is not an easy task. To start with, most of the sites for photographing this subject matter are remote. However, this increases the chances for serious photographers versus everyday amateurs.

Coal Power Plants

Before all the coal power plants are shut down, some of us better go take photos of them. I have lots of work to contribute to that genre; images 6–1 and 6–2 are two examples. To create them, I visited the same site on two consecutive days. Image 6–1 was shot near the midday hour; image 6–2 was taken early in the morning. The weather conditions in image 6–2 created mesmerizing light. The cloud was thick yet penetrable by the sunlight, creating a halo around the sun. The backlit coal plant and eerie-looking sky made this an iconic image. On the other hand, the blue sky in image 6–1 suggests a less gloomy mood. Both can appeal to buyers, depending on their ideas about how to depict this subject matter.

> " Most of the sites for photographing this subject matter are remote. "

▶ VISUAL GRAMMAR

Negative Space

Users of stock photos often add text to the composition. Therefore, leaving negative (open) space in the image is an important compositional consideration. In images 6–1 and 6–2, I included plenty of open sky around the power plant. Not only does this compositional element carry the message of the facility's impact on our air, it also leaves plenty of space for graphic designers to play with adding text and other elements.

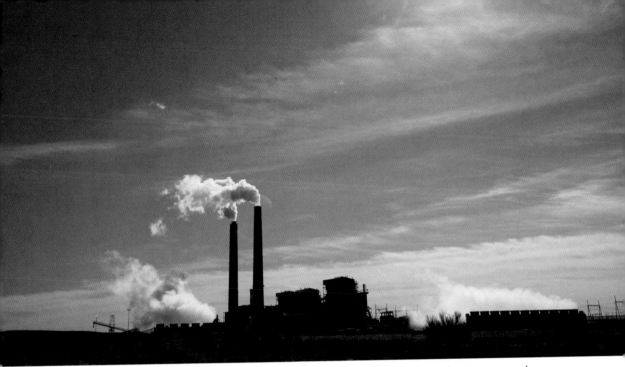

Image 6-1. KEYWORDS: coal; coal power; power generation; fossil fuel; smoke; smog; smoke stack; steam; electricity; electric; energy; coal energy; fossil energy; carbon; carbon emission; greenhouse gas; global warming; climate change

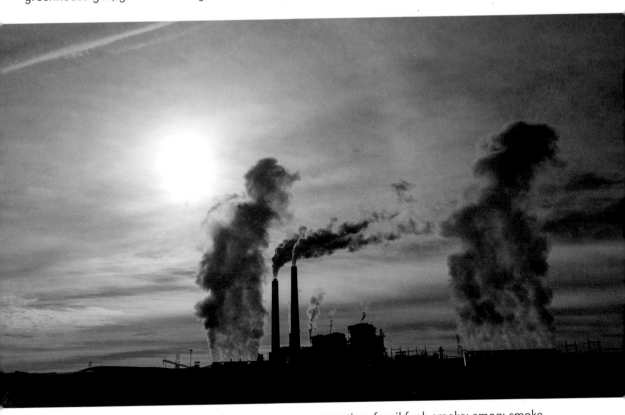

Image 6-2. KEYWORDS: coal; coal power; power generation; fossil fuel; smoke; smog; smoke stack; steam; electricity; electric; energy; coal energy; fossil energy; carbon; carbon emission; greenhouse gas; global warming; climate change

Vanishing Point

The vanishing point is the point at which receding parallel lines, viewed in perspective, appear to converge. In photography, including lines that converge toward a vanishing point can help us enhance the sense of space. Including a prominent vanishing point infuses an image with a strong sense the three-dimensional world it portrays. Take **image 6–3**, for example. The power lines and the rows of sorghum converge to a vanishing point at the lower right corner of the composition. Imagine this image with only the wind farm and without the lines of the power cables and the field. The sense of vastness would be diminished.

Wind Farms

On a more progressive and hopeful note, **images 6–3** through **6–7** depict wind farms in different surroundings and under different lighting. **Image 6–3** is an interesting combination of industry and agriculture, as the wind farms stood on a sorghum farm with a crop ready to be harvested. **Image 6–4** is an aesthetic departure from the most common image showing front-lit wind turbines; therefore, it has a good chance of standing out among competitors' thumbnails. **Image 6–5** put the wind turbines behind the red fence, suggesting inaccessibility, a concept that might match some graphic designers' (or their boss's) minds. **Images 6–6** and **6–7** are two views of wind farms in the Mojave Desert. Both images feature a low horizon and big sky, leaving comfortable room for the addition of other graphic design elements.

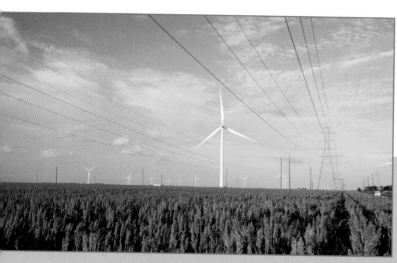

Image 6–3. KEYWORDS: agriculture; electric; electricity; farm; green energy; renewable energy; sorghum; wind farm; wind power

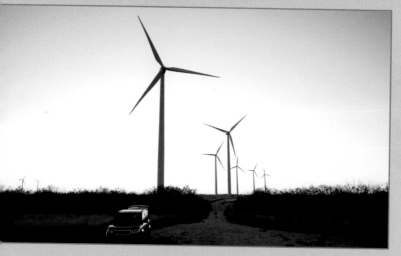

Image 6–4. KEYWORDS: Abilene; car; clean energy; renewable energy; sunset; twilight; wind farm; wind mill; wind power; wind turbine

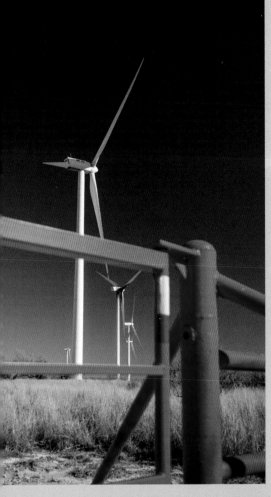

Image 6–5 (left). KEYWORDS: Abilene; clean energy; farm; fence; red; renewable energy; wind farm; wind mill; wind power; wind turbine

Image 6–6 (below). KEYWORDS: cacti; cactus; California; Mojave Desert; renewable energy; sky; wind farm; wind power; wind turbine

Image 6–7 (bottom). KEYWORDS: cacti; cactus; California; Mojave Desert; renewable energy; sky; wind farm; wind power; wind turbine; sunset; dusk

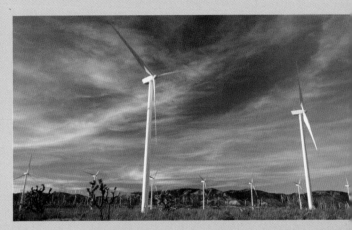

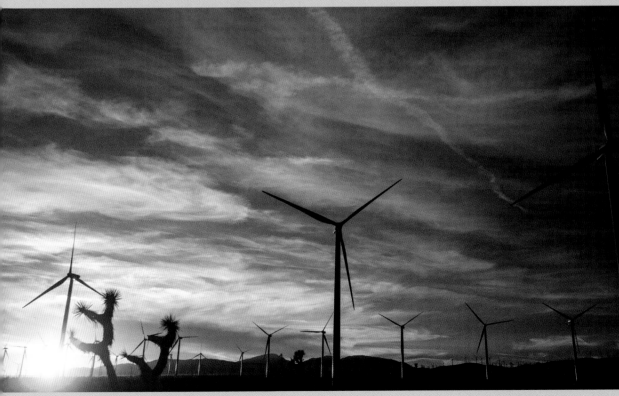

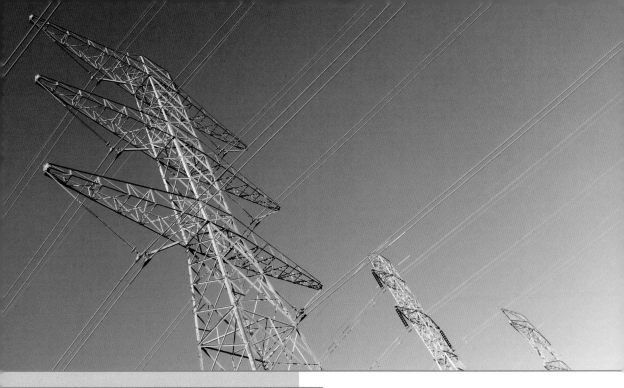

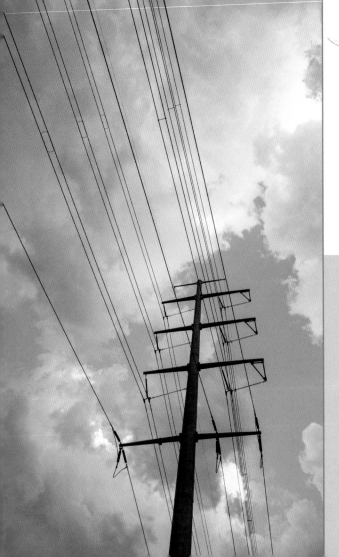

The Grid

The transportation of electricity through the grid happens right above us—yet most of us are visually immune to these structures or consider them eyesores. However, I find them strangely awe-inspiring. The electrical grid is the one of the most vulnerable parts of our infrastructure. For sure, it will be a talking point for years to come. **Images 6–8** through **6–10** are three examples of depicting these facilities.

Image 6–8 (top). KEYWORDS: electric; electricity; energy; grid; ground wire; hot wire; neutral wire; steel; tower

Image 6–9 (left). KEYWORDS: cable; conductor; electric; electricity; energy; grid; ground wire; hot wire; insulator; power line; tower; wire

Image 6–10 (facing page). KEYWORDS: cloud; electric; hot wire; insulator; light pole; power; rainbow; sky; street light; transformer; wire

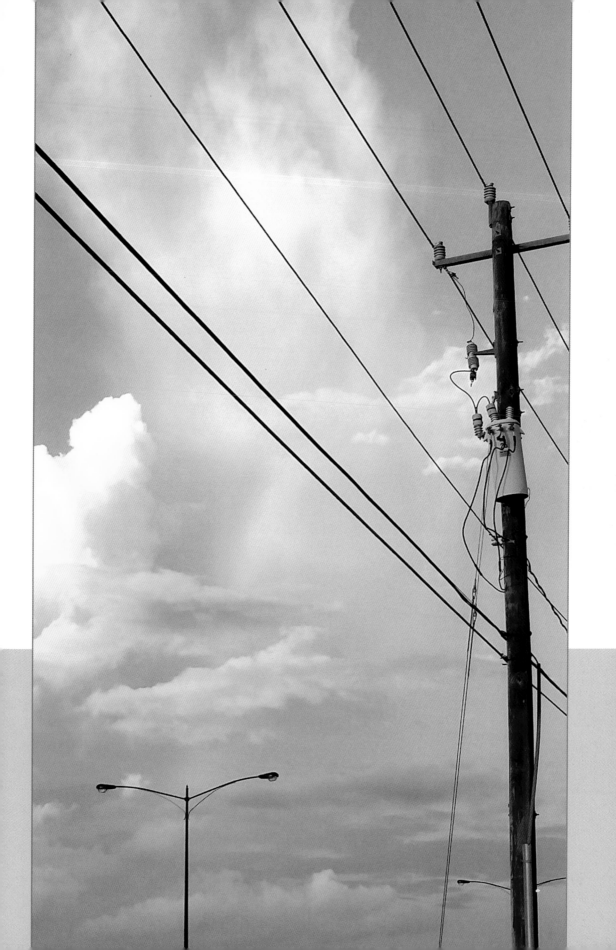

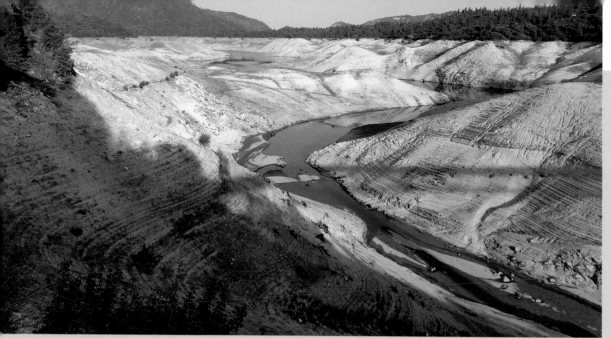

Image 6-11. KEYWORDS: California; drought; environment; Lake Shasta; soil; water; water shortage

Image 6-12 (above). KEYWORDS: brush fire; California; drought; fire; fire hazard; grass; haze; panorama; prairie; smoke; sun; sunset

Image 6-13 (below). KEYWORDS: California; Shasta Lake; dam; reservoir; lake; fresh water; irrigation; drinking water; drought; water shortage

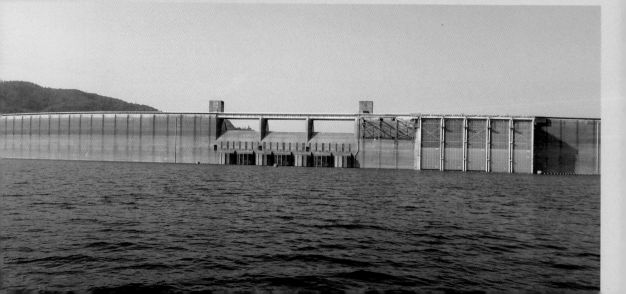

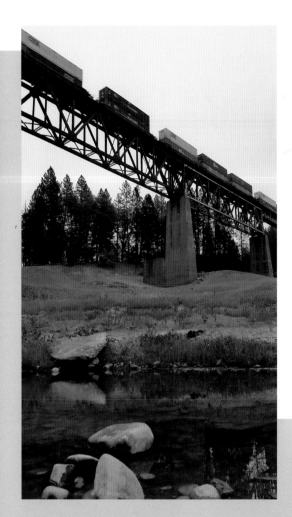

Drought

California's severe drought that started in 2015 (and may be just the beginning of a new norm) is documented in **images 6-11** through **6-14**. Low water levels, brush fires, bridges with exposed foundations, and a dam that supplies California's lifeline—these are images that send strong messages.

Retreating Glaciers

Although the retreat of the glaciers cannot be portrayed in a still photograph, **image 6-15** is still a very good visual cue for such a topic. The overview of the glacier and the large sky make it a perfect composition for additional graphic elements.

Image 6-14 (left). KEYWORDS: bridge; California; drought; environment; Lake Shasta; soil; train; water; water shortage

Image 6-15. KEYWORDS: Alaska; climate change; glacier; Glacier Bay; global warming; Margerie Glacier; melt; melting; mountain; National Park; peak; retreating; sea; sea level; water

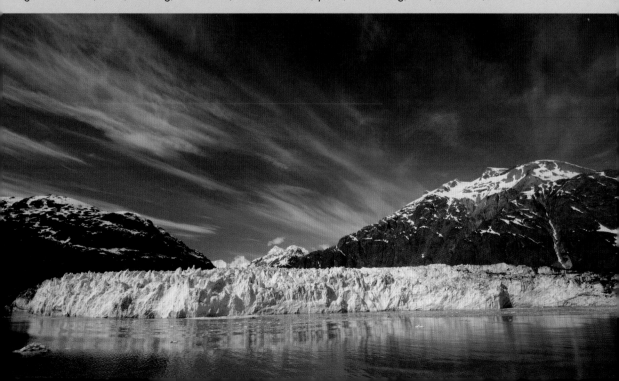

Inside the Mind of a Graphic Designer
Interview with Rhonda Schaller

Mark: When you work on a project, can you tell me how the search of stock photos fits into the process?

Rhonda: Sometimes there aren't enough funds in a project budget to hire a photographer—or I'm not in the location, or I don't have the right skills, time, or equipment to take a photo myself. Stock photos are one way to overcome those challenges, but they are equally great at using along with original images to help communicate a message and aid understanding.

Mark: After you obtain the stock photos, how do you integrate them into your design?

Rhonda: This is very dependent on the scope of the project. In these two examples, I chose to use them in a collage. On the web site I also used them as straight photographs for a gallery

Top left and right–Sample designs by Rhonda Schaller.
Bottom–Original image by Mark Chen.

Above–Sample design by Rhonda Schaller. **Right**–Original images by Mark Chen.

66 What I can do with stock photos is help create a mood or give a greater understanding of the area. 99

page. I've used stock photos in the past to build background images for company folders. To represent the services of a hospitality consulting company, I used stock images of construction, maid service, and office support.

Mark: Is it easy to find the stock image you are looking for?

Rhonda: No. The drawback of stock images are that they may not be specific enough. I've done a lot of design work for real estate companies that need photos of specific property. What I can do with stock photos, though, is help create a mood or give a greater understanding of the area. I can usually find stock photos of landmarks or, in the case of my Florida real estate clients, photos of the coastline and beach.

Mark: Do you have specific stock photo agencies that you search on? If yes, what are they?

Rhonda: I've primarily used istockphoto.com, a subsidiary of Getty Images. Getty Images is a great place for premium photos and iStock is less premium but marketed still as signa-

Negative Space

Negative space is a relative concept. There is no clear definition as which area is considered "negative" or which area is "positive." Take the horizontal image to the right, for example. This very tight composition of a snow plow at the front of a locomotive is seemingly without any negative space. However, many graphic designers would use the black part of the machine as the negative space. This is due to the colors, the forms, and even the implication of how it works: the red part is the tip and, therefore, the center of attention.

Top—Sample design by Rhonda Schaller. **Bottom**—Original image by Mark Chen.

Left—Sample design by Rhonda Schaller. **Above**—Original image by Mark Chen.

ture and essential images. I've also recently discovered Pixabay which has crowd-sourced images by those who join, but with a creative commons license that doesn't require attribution. I've used a few photos from them in the Silver Spike project, but I have not used any of their images for commercially-driven paid projects. In an educational setting, where students are creating work for a portfolio and not for a client, I don't want students using other people's art or photos, so Pixabay is helpful when they aren't able to generate their own photos or art. A nice thing on their web site is that a search brings up options for both the Pixabay crowd-sourced images or stock photos for purchase at Shutterstock.

Mark: Do you have any advice for stock photographers? Do you ever think, "I wish they would have photographed this or that!"?

Rhonda: I wish they would photograph cows on pogo sticks—oh wait, Getty Images already has that. Who thinks of these things? And how would you use it? I'm guessing this is about milkshakes, but I don't particularly want to think of bouncing cows and shaking udders while enjoying that frozen treat. I'm not sure how often that image is purchased, but it's available. It's also a bit unexpected—and I like the thought of that, even if I can't use it in a real project. I know I have had "I wish" photo requests while working on projects in the past, but I haven't harbored any grudges against stock photographers when I couldn't find what I was looking for. So I don't have a running wish-list. However, I can generally find plenty of what I call "advertising slick" posed, beautiful model stock photos, but less of the real and practical. Show me real people in real situations, like work settings, homes, or in locations (generic or landmark-specific), etc.

Left–Sample design by Rhonda Schaller. **Below**–Original image by Mark Chen.

7. Parks and Landscapes

The wonders of the natural landscape remain one of America's most alluring attractions to the world. Our national parks host landmarks that are globally unique.

Yosemite

Images 7–1 and **7–2** showcase, arguably, the single-most unique monolith in the world: Half Dome at Yosemite Na-

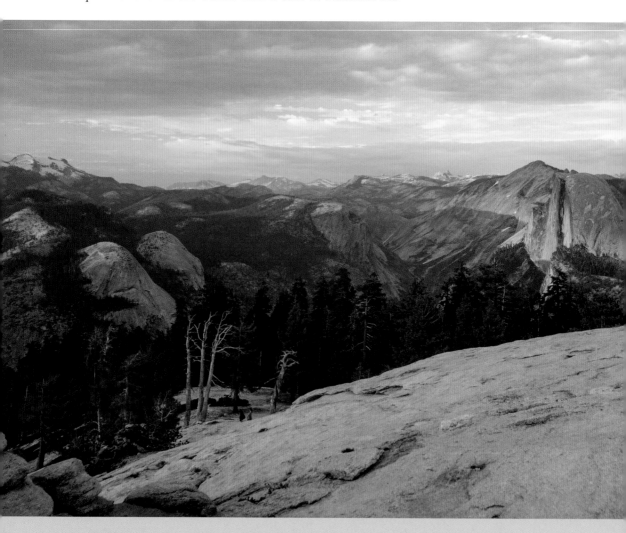

tional Park. Ansel Adam's fame was closely tied to this park, and many of his most iconic images feature it. One tip for photographing landmarks such as Half Dome, which must have been photographed millions of times, is to photograph it when the conditions around it are special. **Image 7–1** caught the last few seconds of light before sunset, cast squarely on the Dome and nothing else. **Image 7–2** has stunning clouds that are lit by the twilight. Including the small figures in the lower right corner was a plus. They not only give us a reference point for understanding the scale, their obscured identity might also let us get away without model release forms.

66 Our national parks host landmarks that are globally unique. 99

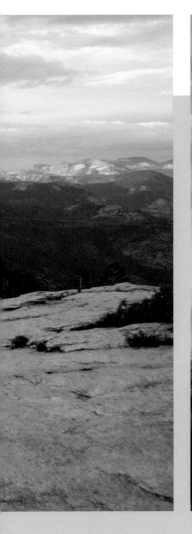

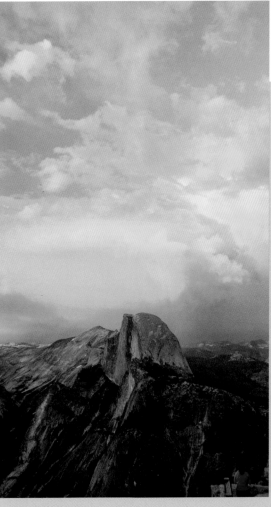

Image 7–1 (left).
KEYWORDS: California; dusk; forest; glacier; Half Dome; hike; mountain; national park; nature; outdoors; rock; sunset; Trinity Point; U shape valley; valley; Yosemite

Image 7–2 (right).
KEYWORDS: geology; glacier; granite; Half Dome; Metamorphic rock; nature; tourist; U shape valley; valley; Yosemite

Crater Lake

Oregon's Crater Lake National Park is another one-of-a-kind natural wonder. Crater Lake is a collapsed volcanic caldera that is now flooded with blue water (caused by minerals dissolved in the lake water). Wizard Island, the volcano within a volcano, is the cone shaped island in the middle of the lake. How fascinating is this unusual assemblage of elements (**images 7–3** and **7–4**)?

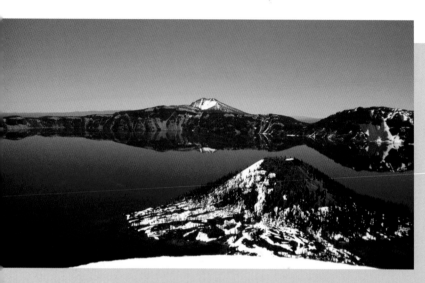

Image 7–3 (left). KEYWORDS: caldera; Crater Lake National Park; national park; nature; Oregon; park; reflection; snow; trees; volcanic; volcanic lake; volcano; winter; Wizard Island

Image 7–4 (below). KEYWORDS: caldera; Crater Lake National Park; national park; nature; Oregon; park; reflection; snow; trees; volcanic; volcanic lake; volcano; winter; Wizard Island

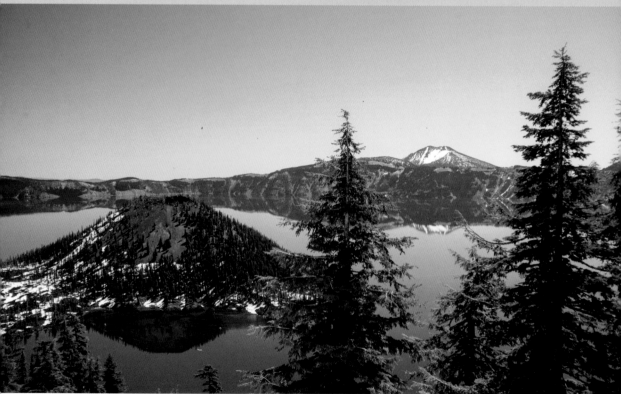

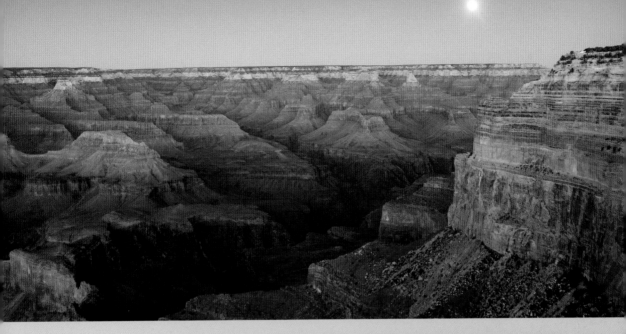

Image 7–5 (above). KEYWORDS: canyon; geology; Grand Canyon; layer; moon; moonrise; national park; rock; sediment; shadow; sunset

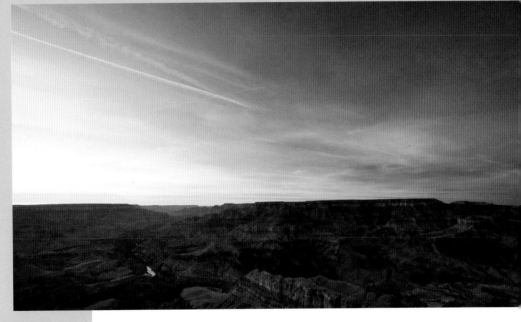

Image 7–6 (right). KEYWORDS: canyon; cloud; dusk; geology; Grand Canyon; layer; national park; rock; sediment; shadow, jet trail

The Grand Canyon

The Grand Canyon has the geological history of the world recorded in its layers, which date back 1.8 billion years at the deepest part of the canyon. **Images 7–5** and **7–6** depict these intricate layers under the very special conditions provided by the last of the sky's light after the sun had set.

Image 7–7.
KEYWORDS: batholith; Enchanted rock; Fredericksburg; geology; granite; inselberg or monadnock; pluton; rock; stone; Texas; texture

Image 7–8.
KEYWORDS: batholith; Enchanted rock; Fredericksburg; geology; granite; inselberg or monadnock; pluton; rock; stone; Texas; texture

Enchanted Rock

The Enchanted Rock State Natural Area in Texas is home to the second largest granite dome in the USA. Climbing on this rock, you might see features like those shown in **images 7–7** and **7–8**. These peeling-off layers of rock make you feel like a little ant walking on an onion. The color and texture are two supporting attractions that come after the unique forms.

Saguaro National Park

Images **7-9** and **7-10** are saguaros at Saguaro National Park in Arizona. These giant cacti have lots of individuality and many personalities. No wonder some Native Americans regard them as people. These two images showcase them with great simplicity. Isolating the cacti is a great departure from the more common images that depict a whole forest of saguaro.

> 66 Isolating the cacti is a great departure from the more common images. 99

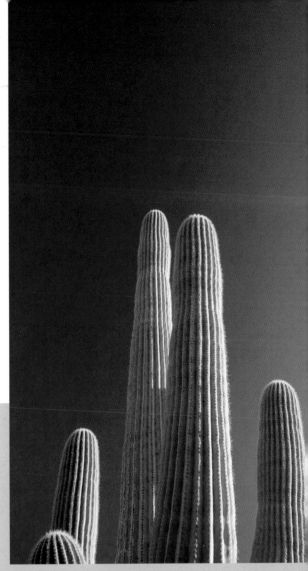

Image 7-9 (right). KEYWORDS: cactus; Carnegiea gigantea; desert; moon; plant; Saguaro; Saguaro National Park; sky

Image 7-10 (below). KEYWORDS: cactus; Carnegiea gigantea; desert; plant; Saguaro; Saguaro National Park; sky

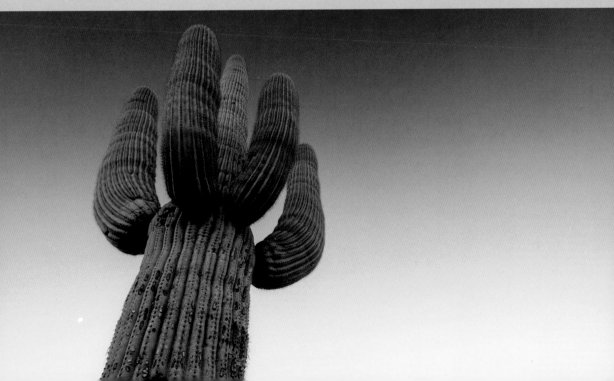

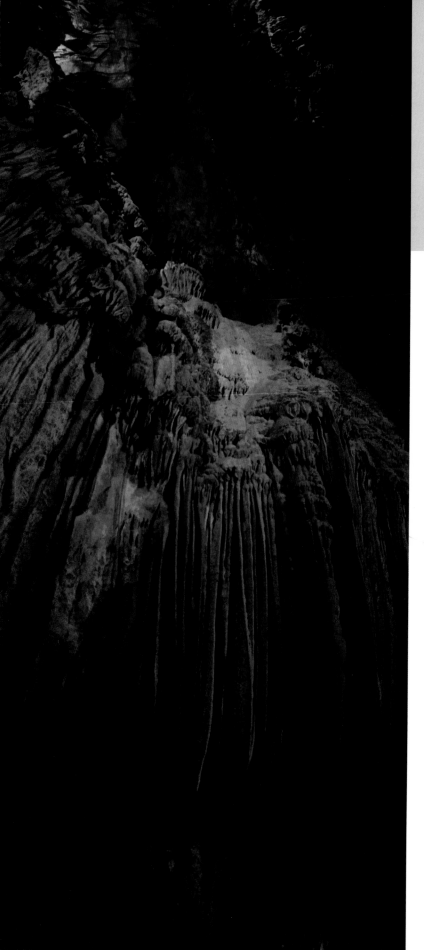

Image 7–11 (left) . KEY-
WORDS: California; cavern;
cave; limestone; Shasta Lake
Cavern; solutional cave

Image 7–12 (facing page).
KEYWORDS: California; cav-
ern; cave; limestone; Shasta
Lake Cavern; solutional cave

Shasta Lake Caverns

Limestone caverns have
amazing formations. They
are also one of the hard-
est scenes to photograph
because of the dim illumina-
tion and wide scope of view.
Our eyes can easily adapt to
these challenging conditions,
but most cameras aren't that
good. Lo and behold, the
Samsung S5 delivered stun-
ning quality in these images.
Even zoomed in, the noise
level is amazingly low.

❝ Our eyes can
easily adapt to
these challenging
conditions, but most
cameras aren't that
good.❞

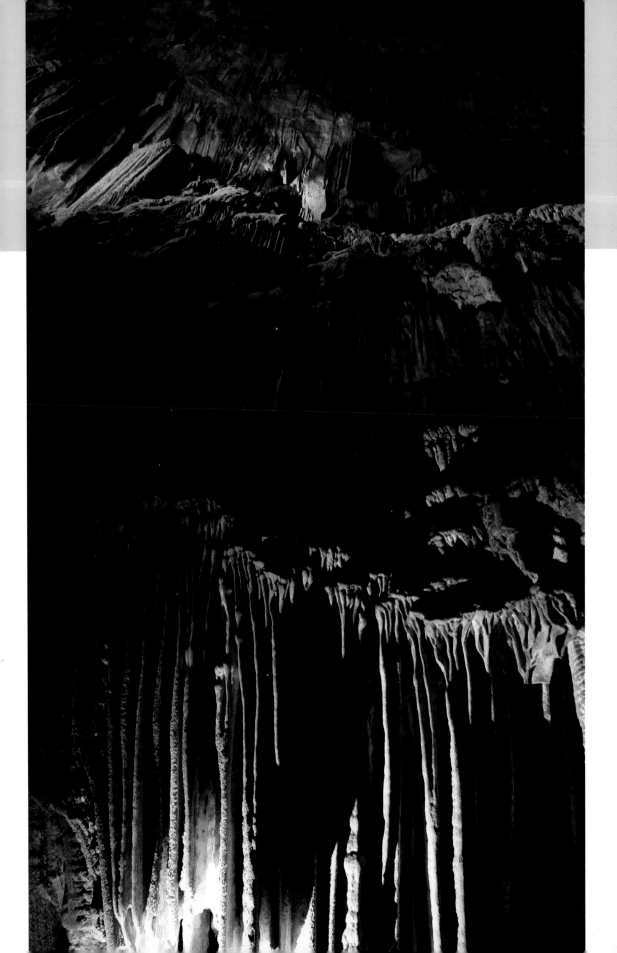

8. Lifestyles

Bicycles and Cycling

Lifestyles shift with the zeitgeist—but the funny thing is that trends often circle back into popularity. When cars were not so affordable, people biked more. Now that people drive a lot, we think it is healthier and better for the environment to ride our bikes. It is now a trend for cities to designate bike routes and provide bike rentals.

As a result, images depicting this trend are in demand and I have been especially paying attention to sights that reflect this change. **Images 8-1** through **8-11** are images produced under this speculation. **Images 8-1** through **8-4** are markings for bike routes. Ideally, there would a biker zooming past these markers, but I had no luck witnessing such an occurrence. (Perhaps this is indicative of the requirement for more promotional efforts?)

Image 8-1 (top). KEYWORDS: bicycle; bicycle lane; bike; bike lane; bike route; commute; street; traffic

Image 8-2 (bottom left). KEYWORDS: bicycle; bicycle route; bike; bike route; car; commute; health; house; lifestyle; neighborhood; sign; street; trees; urban

Image 8-3 (bottom right). KEYWORDS: bicycle; bicycle route; bike; bike route; car; commute; health; house; lifestyle; neighborhood; sign; street; trees; urban

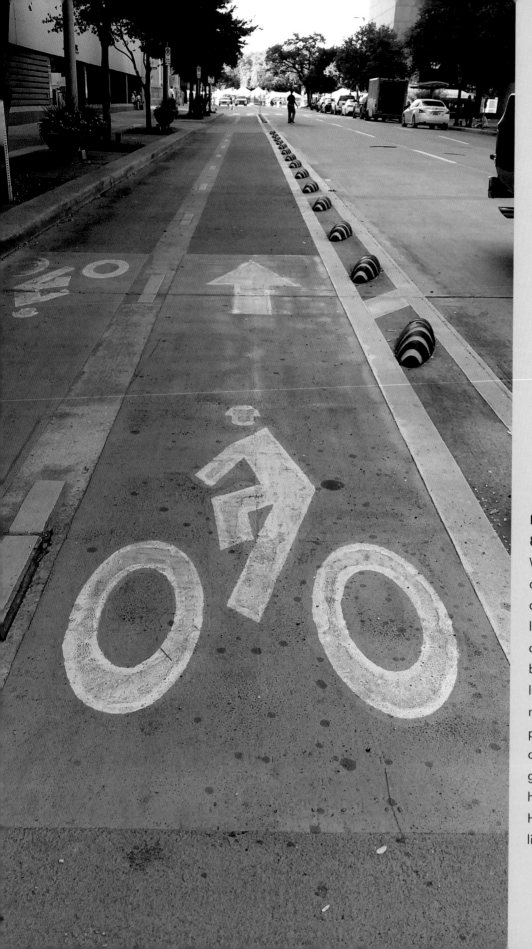

Image 8–4. KEYWORDS: arrow; bicycle; bicycle lane; bicycle route; bike; bike lane; bike route; city planning; commute; green; health; Houston; lifestyle

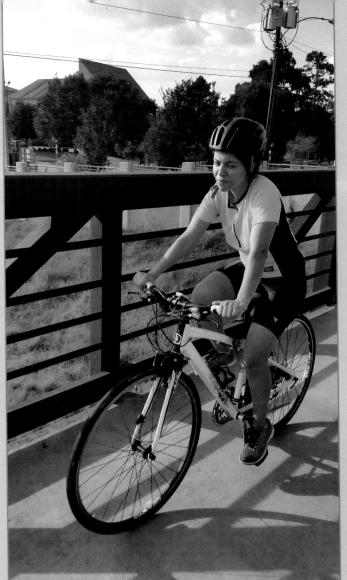

Image 8–5 (left). KEYWORDS: bicycle; bike; bike route; biker; bridge; cyclist; female; fitness; guardrail; health; healthy; helmet; Hispanic; pedaling; safety; woman; yellow

Image 8–6 (below). KEYWORDS: bicycle; bike; bike route; biker; bridge; building; car; fitness; flood channel; health; healthy; helmet; Hispanic; rail; safety; street; woman; yellow

Image 8–7 (bottom). KEYWORDS: bicycle; bike; bike route; biker; bridge; building; car; fitness; flood channel; health; healthy; helmet; Hispanic; rail; safety; street; woman; yellow

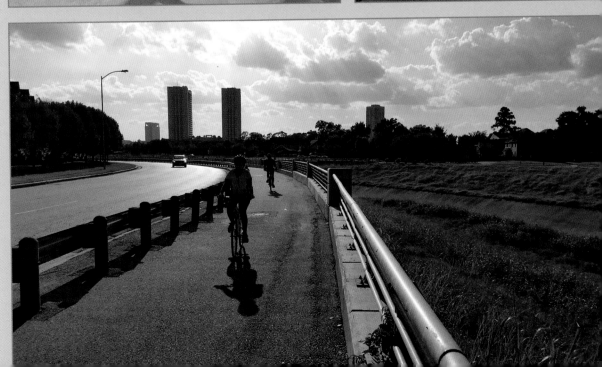

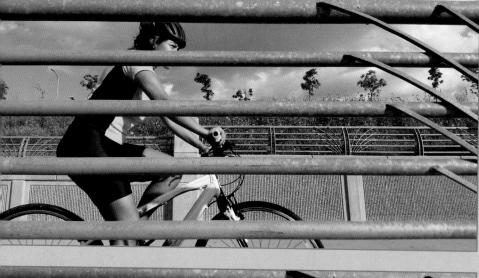

Image 8-8. KEY-WORDS: bicycle; bike; bike route; biker; bridge; fitness; flower; grass; health; healthy; helmet; Hispanic; laugh; safety; sky; street; trees; wave; woman; yellow

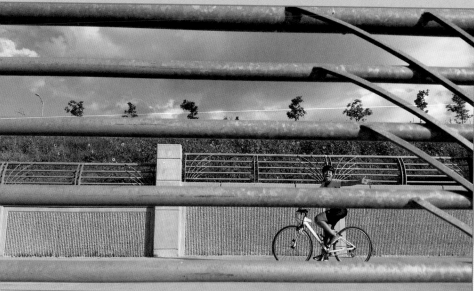

Image 8-9. KEY-WORDS: bicycle; bike; bike route; biker; bridge; fitness; flower; grass; health; healthy; helmet; Hispanic; safety; sky; street; trees; woman; yellow

I then called a friend who is an avid biker to model for me. **Images 8-5** through **8-10** are images produced from this session. Traversing up and down Houston's newest and proudest bike route on a sunny day, they showcase a leisurely bike outing. If you wanted, instead, to showcase commuter biking, you might want to shoot on a weekday with busy traffic—and you could have the model dress in office attire with a backpack, perhaps. **Image 8-11** (page 88) is another take on the urban cycling theme, this time

with an identifiable urban landmark: San Francisco's Bay Bridge. Biking in a city is literally presented without any ambiguity.

▶ VISUAL GRAMMAR
The Rule of Thirds

Images 8-8 and **8-9** place the biker at the Rule of The Thirds points. This gives the biker some edge when competing with the rails' strong parallel lines. It helps reign in the viewer's attention and keep their gaze from sliding too freely on the lines.

Image 8–10.

KEYWORDS:
bicycle; bike; bike
route; biker; bridge;
fitness; health;
healthy; helmet;
Hispanic; safety;
woman; yellow

▶ VISUAL GRAMMAR

Vanishing Point

The direction of
the vanishing
point, if com-
bined with the
imaginary line
of the thrust
of movement,
can create a
strong sense
of dynamics.
Image 8–10
is one such
example. The
direction of the
biker's thrust
line, the vanish-
ing point at the
convergence of
the road, and
its surrounding
structure all
point to the
left—slightly off
the frame.

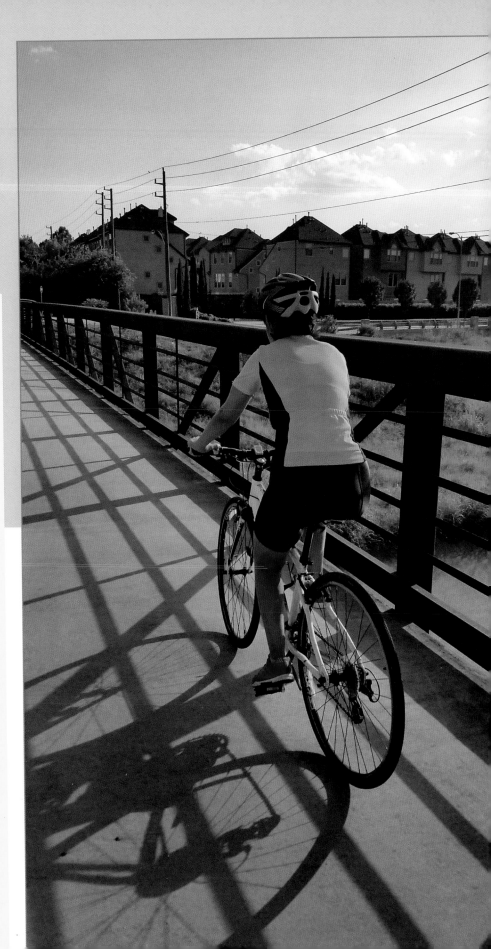

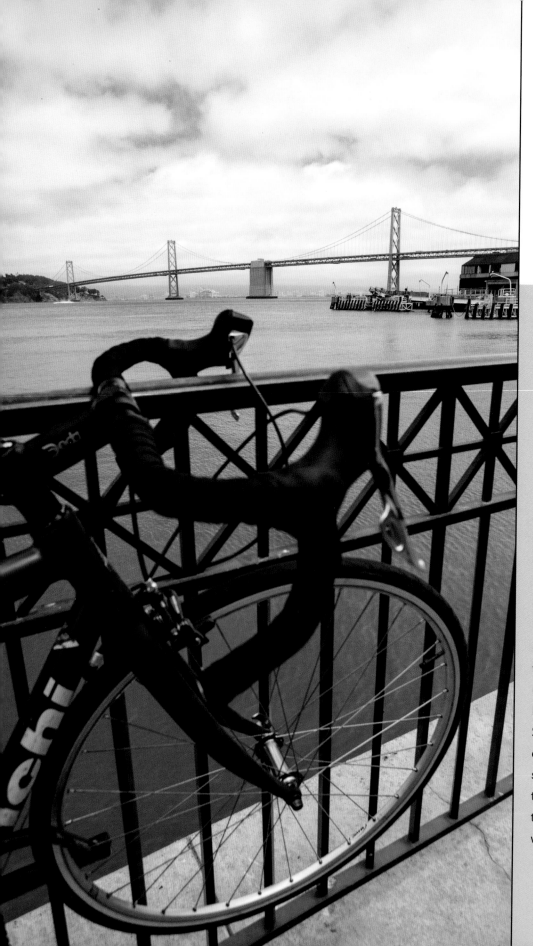

Image 8–11. KEY-WORDS: Bay Area; Bay Bridge; bicycle; bike; fence; lock; rail; San Francisco; San Francisco Bay; sports; transportation; workout

A shot like **Image 8–12** may be used as a contrasting companion image to the biking-themed images. This is a stacked parking facility in the densely populated New York City. This might ease the parking problem to a degree, but it is not a pretty sight. The anxiety of life in New York City has to be relieved from time to time, and some of the city dwellers choose to do this by kayaking on the Hudson River—as in **image 8–13**.

Image 8–12 (top). KEYWORDS: automatic parking; car storage lift; New York; parking; parking lift; parkmatic; robotic parking; SpaceSaver parking; stacked parking

Image 8–13 (bottom). KEYWORDS: boat; canoe; canoeing; George Washington Bridge; Hudson River; New Jersey; New York; New York City; watersport

What's Special Around You

Another tip for stock photographers is to create images of whatever is special or unique around you. I happen to have a mom who is a Chinese watercolor painter, so it is only natural that I would photograph her creating these beautiful pieces of art. **Images 8-14** through **8-16** show her work, her equipment, and one of her paintings in the making.

Image 8-14 (above). KEYWORDS: autograph; backlit; calligraphy; Chinese; Chinese calligraphy; handwritten; ink; rice paper; script; strokes; studio; texture

Image 8-15 (left). KEYWORDS: color palette; dish; grinder; ink; jar; painting; studio; vase; watercolor

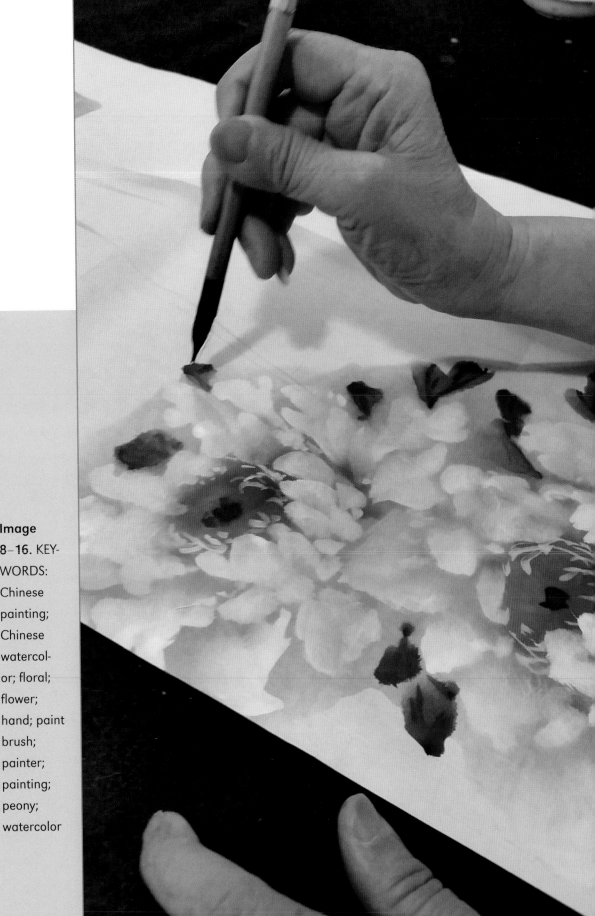

Image 8–16. KEYWORDS: Chinese painting; Chinese watercolor; floral; flower; hand; paint brush; painter; painting; peony; watercolor

Watch for Impromptu Moments

Finally, **image 8–17** shows an impromptu image that was taken while one of my students was at work in a photography workshop. Standing behind her, I created a pure and symmetrical composition that I find fascinating. The scene looks plush, leisurely, and well kept—a perfect depiction of a rosy suburban lifestyle. I don't necessarily endorse that lifestyle, but the image sure has an appeal for the visual communication of the theme.

Image 8–17. KEYWORDS: back; black hair; grass; green; hair; hat; negative space; shoulder

9. Structure Over Identity

Photography is widely recognized as the medium of reality. This might be true for most cases, but from time to time, a photograph can take us on a trip that is a departure from our regular sense of reality. The stock images in this chapter have this effect. By emphasizing the structure of the subject above its identity, the images lead viewers away from identifying the objects to appreciating their essence.

Leaves and Branches

Image **9–1** is an upward shot taken under a lush canopy of branches and leaves. The backlight made the leaves glow under the blue sky. The silhouette of the branches, the leaves, and the sky formed an abstract look—

▶ VISUAL GRAMMAR
Texture

Texture is a fine, repetitive pattern—sometimes random and sometimes with a structure. In a two-dimensional print or digital display, texture provides a sense of the physical character, or touch, of the subject. In stock photography, texture can be a great asset for a graphic designer because it adds interest without overwhelming the other elements of the design. **Image 9–1**, a canopy of leaves and tree branches with a open composition, is a great example of texture. The texture in this image, with its pleasant colors and outdoor context, makes the image a versatile background.

Image **9–1.** KEYWORDS: branch; green; leaf; plant; shade; sky; texture; tree

although we can certainly still tell these are trees. With this veiled context, the image can be used for a wider range of visual communication. Trees could be the subject matter of the design, or the image could simply be used as a texture with a uplifting and invigorating outdoor theme.

Sunlight, Sky, and Metal

The side of a train caught my attention when an intense sunlight reflected from its less-than-perfect surface (**image 9–2**). The chrome panel with the dents, clearly from years of service, is a great mix of the rigid and the organic. Similarly, the girders of a steel bridge in **images 9–3** and **9–4** are a testimony to both the human determination to build and the natural process by which the materials are reclaimed, as the paint peels off and the steel rusts.

Image 9–2 (below). KEYWORDS: dent; metallic; plate; reflection; scratch; sheet metal; steel; texture; train

Image 9–3 (right). KEYWORDS: beam; cantilever bridge; Cincinnati; Clay Wade Bailey Bridge; girders; Ohio; rivet; sky; steel; structure; trusses

Image 9–4 (below). KEYWORDS: beam; cantilever bridge; Cincinnati; Clay Wade Bailey Bridge; girders; Ohio; rivet; sky; steel; structure; trusses

Interior Design

Images 9–5 and **9–9** are studies of a contemporary building and the furniture that is housed within it. The simple lines and pure colors, accented by the light and shadow, provide versatile backgrounds for any visual communications with a modern essence.

66 **The simple lines and pure colors, accented by the light and shadow, provide versatile backgrounds.** 99

Image 9–5 (top). KEYWORDS: architecture; beam; building; canopy; column; mesh canopy; Rice University

Image 9–6 (bottom). KEYWORDS: architecture; beam; building; canopy; column; mesh canopy; Rice University

Image 9-7 (top). KEYWORDS: blue; chair; curve; cushion; ergonomic; light; modern; outdoor chair; outdoor furniture; shadow

Image 9-8 (center). KEYWORDS: blue; chair; coffee table; concrete; curve; cushion; ergonomic; light; metal; modern; outdoor chair; outdoor furniture; round; shadow; table; texture

Image 9-9 (bottom). KEYWORDS: blue; chair; coffee table; concrete; curve; cushion; ergonomic; light; metal; modern; outdoor chair; outdoor furniture; round; shadow; table; texture

Purely Abstract

While **images 9–10** and **9–11** both have hard-to-discern subjects, they are indeed completely different: one is a backlit close-up of a Chinese jelly dessert while the other is a building's reflection on a pond. The magic for both images is the same: the light. The backlighting turned the jelly into edible jewels and the setting sun transformed the building into a brilliant golden nugget. With the blue sky as the background, the choppy surface distorted the building into an abstract painting by Mother Nature.

Image 9–10 (top). KEYWORDS: aiyu jelly; bubble; cubes; dessert; drink; food; gelatin; jelly; sweet; Taiwanese; Taiwanese dessert

Image 9–11 (bottom). KEYWORDS: abstract; blue; distort; geometric; pattern; reflection; shapes; texture; water

10. Architecture

Image 10–1. KEYWORDS: architecture; building; Chicago; city; closed composition; hotel; office; sky; skyscraper; Trump Tower; urban; vanishing point

envy architects. Not only do they have the rare profession that crosses over between art and science, but they can also play god by creating an environment for the people. Unable to satisfy my envy in this lifetime, I choose to photograph architecture instead.

Structures as Sculpture

Although the structures that architects create serve as living and working spaces, they are also pieces of art, not unlike gigantic sculptures. **Images 10–1** through **10–7** were created with that idea in mind. Trump Tower (**image 10–1**),

the arch of St. Louis (**image 10–2**), two pedestrian bridges in Denver (**images 10–3** and **10–4**), the Denver Art Museum (**image 10–5**), and the Bass Performance Hall in Fort Worth (**image 10–6**)—none of these subjects are really portrayed as buildings; they are presented for their formal beauty. The fins (**image 10–7**) are Menil Collection, designed by Renzo Piano, and function to bring in natural light into the gallery without allowing direct light to shine on the art—but they are pure formal fun in my image.

66 **None of these subjects are really portrayed as buildings . . .** 99

Image 10–2 (top right). KEYWORDS: arch; architecture; Gateway Arch; Jefferson National Expansion Memorial; Missouri; St. Louis Arch; St. Luis

Image 10–3 (left). KEYWORDS: architecture; cable; cable-stayed bridge; Denver; footbridge; Millennium Bridge; pedestrian bridge; post-tensioned; structure

Image 10–4 (bottom right). KEYWORDS: architecture; cable; Denver; footbridge; Highland Bridge; pedestrian bridge; structure

Image 10–5 (above). KEYWORDS: architect; architecture; Daniel Libeskind; deconstructivism; Denver; Denver Art Museum; postmodernism

Image 10–6 (right). KEYWORDS: angel; Bass opera house; concert hall; horn; music hall; Nancy Lee and Perry R. Bass Performance Hall; office building; sculpture; skyscraper; trumpet; Wells Fargo

Image 10–7 (below). KEYWORDS: architecture; ceiling; fins; Houston; Menil Collection; museum; Renzo Piano

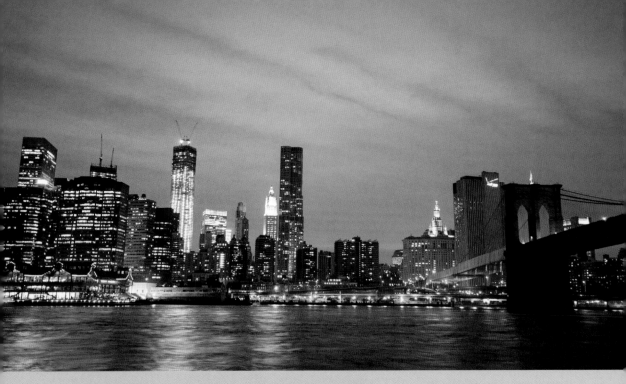

Image 10-8 (above). KEYWORDS: Brooklyn Bridge; city; dusk; East River; Freedom Tower; light; Manhattan; New York; night; skyline; under construction; urban

Image 10-9 (left). KEYWORDS: bridge; city; Dallas; skyline; sunrise; sunset; train; transportation

The Function of Architecture

Images 10-8 and **10-9**, two images with interestingly similar compositions (not intended), depict architecture with its end users (lots of them!) in mind. **Image 10-8** shows New York City's Brooklyn Bridge. This bridge, over a century old, is going strong and still serving a modern city. **Image 10-9** portrays Dallas with an unnamed railroad bridge. The payloads of the trains are clearly industrial. These are two similar images, both depicting human activities, but they are still drastically different.

> " This bridge, over a century old, is going strong and still serving a modern city. "

Images **10-10** and **10-11** are good examples of images that can be created as a close examination of people living in the spaces designed by architects. **Image 10-10** shows a pedestrian (my wife, to be exact—it is good for a stock photographers to have companions around, so model releases aren't too hard to obtain!) walking up some stylishly designed stairs. **Image 10-11** depicts a car zooming through a steel bridge in Chicago, one of many such structures that connect the city on both sides of the Chicago River.

Image 10-10 (right). KEYWORDS: Denver; handrail; pedestrian; rule of thirds; shadow; stairs; walk

Image 10-11 (below). KEYWORDS: beam; blur; bridge; car; Chicago; Chicago River; girder; mesh; motion; motion blur; movement; moving; rivet; steel; traffic; truck

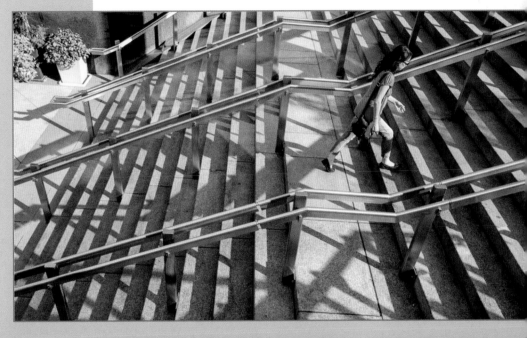

**Image
10–12.**
KEY-
WORDS:
architec-
ture; build-
ing; city;
Dallas;
Fountain
Place;
office;
skyscrap-
er; Texas;
urban

Image 10-13.
KEYWORDS: city; commerce; Fort Worth; modern architecture; office building; Texas; Trinity River Campus; urban

> 66 The viewer's attention needs to be reined in, especially in this era of short attention spans. 99

Conventional, But With a Twist

Images **10-12** and **10-13** are two more conventional views of architecture, but there are still some twists. **Image 10-12** "frames" the famed Dallas landmark, Fountain Place, with a dark street, showcasing it as the only brightly lit structure in this composition. In **image 10-13**, a cluster of office buildings are presented in a rhythmic way that is in sync with the style of the architecture.

▶ VISUAL GRAMMAR
Framing

The viewer's attention needs to be reined in, especially in this era of short attention spans. One tool to achieve this is framing: using secondary subjects to create a margin around the subject of interest in order to shine a spotlight on it. **Image 10-12** is an example of framing. The dark street and pressing buildings on its sides direct all the attention to Fountain Place, one of the landmarks of downtown Dallas. This composition was made possible by light at a certain time of the day, when only our subject of interest was well lit.

Look for Rare Opportunities

Rarity is one of the keys to success in stock photography—and even a commonplace subject can have a rare moment. Lincoln Center's concert hall is not an unusual sight, but seeing it covered in scaffolds for renovation, as shown in **image 10–14**, was unusual. Whether or not it is identifiable as the prestigious Lincoln Center is not critical; an image of a concert hall under renovation is not so easy to find in the stock photography market.

> ❝ Rarity is one of the keys to success in stock photography . . . ❞

Image 10–14 (above). KEYWORDS: backstage; closed; concert hall; construction; dark; empty; hall; Lincoln Center; music hall; musical; opera house; renovation; scaffold; seats; stage; theater

Image 10–15 (facing page). KEYWORDS: supreme court, New York, building, architecture, church, twilight, tower, Roman, column

Interview with Michael Wooten

Mark: Tell me about this collection of designs, which I assume are for fictitious clients?

Michael: If *Science Fiction* was a real magazine. I just thought that the first image had

a science-fiction feel to it. Like the snail was entering a wormhole through the mushroom. For the others, I just made the design fit with the image. The next comp *[facing page]* had a surreal feel to it and I thought,

Left–Sample design by Michael Wooten. **Above**–Original images by Mark Chen.

Top–Sample design by Michael Wooten. **Above**–Original images by Mark Chen.

"Why not have a book about these fictitious landscapes?" I thought that the New York one *[page 111]* would make a great travel poster. A post-drought, we-are-still-here kind of travel poster. And the last one reminded me of one of those disaster movies you find on cable television *[page 110]*.

Mark: When you work on a project, can you tell me how the search for stock photos fits into the process?
Michael: It depends on the project. Often, I will take my own photos—but I have used stock photos when needed. Often, it's when I can't easily set up a photo shoot that I will use stock photos.

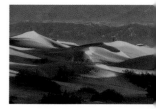

Above—Sample design by Michael Wooten. **Right**—Original images by Mark Chen.

Mark: After you obtain the stock photos, how do you integrate them into your design?

Michael: Usually the client will provide me with a link to whichever service they use. If not, I have my own account. Most sites will let you search for images via keyword search, so I will look until I find that perfect image—or images, as the case may be.

Mark: Is it easy to find the stock image you are looking for?

Michael: It depends on the subject. Most often, yes it is.

Mark: Do you have specific stock photo agencies that you search? What are they?

Michael: Shutterstock is the biggest. There are others like Pixabay that are okay. New Old Stock is amazing. It's a collection of antique photos, many taken by government agencies or discovered in estate sales. Its only downside is that it's not searchable, so you have to scroll until you find the right image.

Flickr can also have some good resources. The Nationaal Archief of The Netherlands has a great Flickr site with lots of pictures from Holland's past. Deviant Art has some good resources, as well.

Below–Original images by Mark Chen. **Bottom**–Sample design by Michael Wooten.

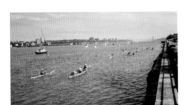

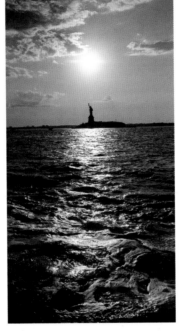

Mark: Do you have any advice for stock photographers?
Michael: I tend to go for the dramatic. Strong lighting, sharp contrast, that kind of thing. Make sure the images are high-resolution and sharp. Keep in mind, we may only need a small part of your photo.

Mark: Some thoughts that go through your mind? Any "I wish they would have photographed this and that" kind of thoughts?
Michael: Scrolling through stock always makes me wish that I spent more time learning photography.

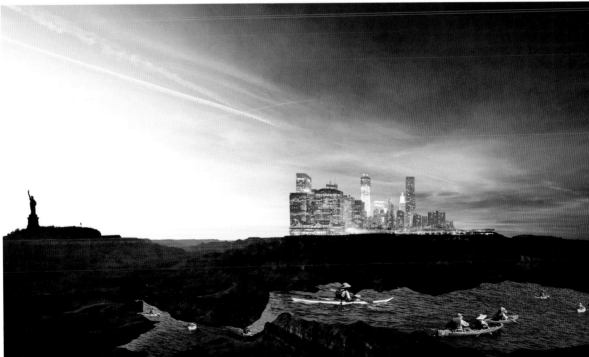

11. The Keen Observer

Photographers can spot interesting subjects that other people would neglect. However, this advantage is not so useful if we can't *capture* that interesting subject in an interesting image. Most often, creating interest comes down to composition and lighting. This chapter collects examples of my work that fall into this category. A good cell phone camera can be the best equipment for these shots because exciting photo ops often appear without prior announcement.

The Mechanical World

Images 11–1 through **11–7** feature some machines I have had the pleasure of knowing. Especially in the age of apps, when tasks are taken care of by running codes in an electronic device, these pulleys and gears remind us how things still have to be done mechanically in the physical world. **Images 11–1** and **11–2** are mechanical elements of ships. The close-up images shows the imperfections—the rust, and peeling paint, and the irregularities due to the limitations of manufacturing technology. These are aesthetically fun and symbolically rich; they remind us of our attempts to make things work. While I was at the pier photographing these elements of marine equipment, I

also photographed the hull of a ship (**image 11–3**). Once again, it was the fight to stop nature from reclaiming this man-made object that interested me.

66 A cell phone camera can be the best equipment for these shots, because photo ops often appear without prior announcement. 99

Image 11–1 (facing page, top). KEYWORDS: aged; axis; axle; bolt; flywheel; gear; lever; machine; machinery; nut; old; rust

Image 11–2 (facing page, center). KEYWORDS: aged; axis; axle; bolt; flywheel; gear; lever; machine; machinery; nut; old; pully; rust

Image 11–3 (facing page, bottom). KEYWORDS: anchor; boat; chain; hull; paint; rope; rust; sea; ship; vessel

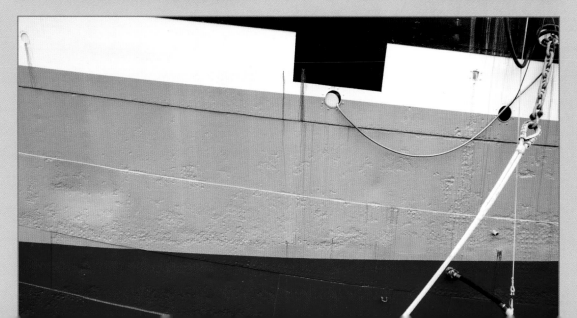

Trains and cars are other types of machinery that tend to invoke nostalgia. **Images 11–4** through **11–7** are images I discovered while lingering at a train on display in a small town in Alaska. **Image 11–4** shows an unusual machine placed at the front of a steam engine to break the snow, so the train won't be stopped by the kind of weather

Image 11–4 (top). KEYWORDS: Alaska; cold; locomotive; machine; railroad; snow; train; train snow plow

Image 11–5 (bottom). KEYWORDS: connecting; railroad; rust; steel; train; train cars; train coupling

► ALL TECH CONSIDERED

Camera Apps

On both Sumsung and Apple phones, the auto exposure program works well and usually provides the optimal image quality. This success (in addition to the fact that there is no aperture to adjust) leaves little reason left for the photographer to take over the settings. But for the sanity of the control freaks, there is an app!

For Samsung's Galaxy and other cell phones running the Android operating system, Camera FV-5 ($4) is an app that gives you DSLR-like control over your cell phone camera. This includes the ability to set the ISO and white balance, to shoot in the program or shutter priority mode, to use exposure compensation and bracketing, and more. For Apple's iPhone, there is Manual ($2), which is aptly named for what it does; it lets you set the exposure manually (including the focus, white balance, ISO, and shutter speed).

Each program has its pros and cons. However, neither is especially handy in improving the shots you get from your cell phone camera. Unlike DSLRs, cell phone cameras simply do not have a lot of settings to play with. In my experience, shooting with the phone's native camera app (using its auto settings) is the best way to ensure you are operating in the device's sweet spot. On a philosophical level, spending minutes pondering and fumbling to get the right exposure settings on your cell phone camera just seems wrong. It defeats the best aspects of shooting with a cell phone camera: quickness and mobility.

we could imagine in a place like Alaska. **Image 11-8** shows a car that probably belongs in a junkyard—except that the owner sees some value in it.

Image 11-6 (right). KEYWORDS: Alaska; caboose; rail car; railroad; railroad car; rust; train; train car

Image 11-7 (below). KEYWORDS: diesel engine; locomotive; railroad; railroad engine; red; rivet; sheet metal; steel; train; weld

Image 11-8 (bottom). KEYWORDS: car; junk; old car; peeled; rust; scratched; vintage car

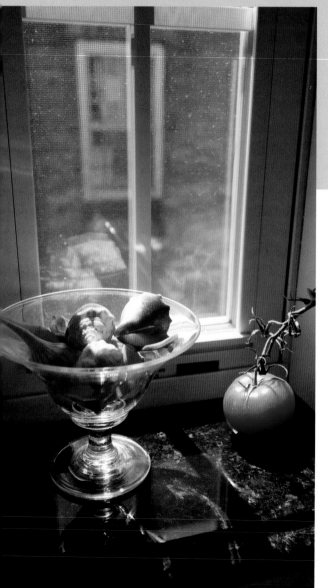

Image 11–9 (above). KEYWORDS: carousel; caulk; Chicago; fairground; Ferris wheel; frame; glasses; greenhouse; merry-go-round; Navy Pier; pipe; plant; reflection; steel

Image 11–10 (left). KEYWORDS: fruit; marble; shell; stem; sunshine; tomato; vegetable; window; windowsill

Reflections

A keen observer can see the world very differently in reflections. **Image 11–9** is not what people normally see in the Navy Pier playground in Chicago. In a sunny corner of a friend's kitchen, I photographed **image 11–10**, which could be used as an image to depict plush lifestyles.

Rarity

Mushrooms thrive on our lawn in wet seasons. Before they are chopped to pieces by the lawn mower, why not photograph them

close-up so we can marvel at their fleeting beauty (**images 11–11** and **11–12**)?

▶ VISUAL GRAMMAR
Open vs. Closed Compositions

Images **11–11** and **11–12** are two more examples of closed and open compositions. **Image 11–11** is closed; all of the mushrooms are completely in sight and the grass, as negative space, surrounds the margins. **Image 11–12** is open, with some of the mushroom going beyond the frame. Open compositions leave more room for imagination as to what's beyond the edge of the image; closed compositions present a complete, well-contained statement.

Image 11–11 (left).
KEYWORDS: Fairy Ring; fungi; fungus; grass; mushroom

Image 11–12 (right).
KEYWORDS: Fairy Ring; fungi; fungus; grass; mushroom

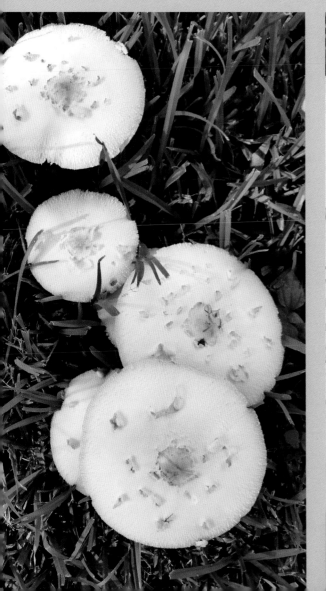

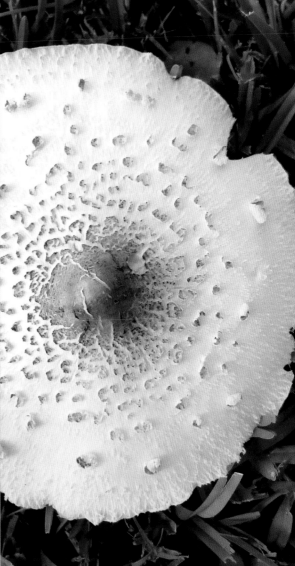

Rarity is also at play in **image 11–13**. This is not a piano keyboard; it is part of a harpsichord, in which the black keys and white keys are reversed.

Unexpected Color Balance

In a cozy cafe in Houston, I found an interesting study in white balance (**images 11–14** and **11–15**). The strange bulb in the lamp got my attention first. Then, I realized that the window, with blurred images of vines, had an interesting dialogue with the lamp. After capturing the image, I was even more fascinated by the comparison of color between the sun-

> ▶ TIPS ON TECH
> ### *Light—Lots of Light*
> In **image 11–15**, the dim light bulb and the window, heavily covered by foliage, did not light up the interior well. But, because the lens was aimed squarely at them, the app decided that the scene was rather bright and set the ISO at 64—a setting that freed me from worry about the noise level.

Image 11–13 (above). KEYWORDS: black key; ebony; harpsichord; instrument; ivory; keyboard; keys; musical instrument; period instrument; white key

Image 11–14 (facing page, top). KEYWORDS: bulb; cafe; color temperature; lamp; light; lightbulb; peel; tungsten; vine; window

Image 11–15 (facing page, bottom). KEYWORDS: bulb; cafe; color temperature; lamp; light; lightbulb; peel; tungsten; vine; window

light and the lamp. The cell phone camera's automatic white balance was clearly aligned to the sunlight's color, making it neutral in the image. Consequently, the light bulb (with a much lower color temperature) appeared yellowish.

Image 11–16. KEYWORDS: antique; Christmas; Christmas tree; decoration; mirror; ornament; shop; shopping; store; toy; window shopping; window

Image 11-17 (left).
KEYWORDS: leaf; leaves; Philodendron; Philodendron bipinnatifidum; plant; rain; tropical; water drops; wet

Image 11-18 (right).
KEYWORDS: leaf; leaves; Philodendron; Philodendron bipinnatifidum; plant; rain; tropical; water drops; wet

Image 11-16 was taken during an involuntary window-shopping trip on Christmas Day in New York City. This antique store seemed to explode with colorful ornaments. A shot through the window (I did not have the choice to go inside, after all) also revealed nice reflections, setting the context and adding to the fun.

Plants

The world of plants has a love/hate relationship with me. I kill them, but I love to photograph them. **Images 11-17** through **11-22** were all photographed on unexpected occasions when photo ops just manifested in front of me.

Spending some time learning the names of plants is important for stock photography; otherwise you can't label them with meaningful, searchable keywords. Finally, to prove my ineptitude in horticulture, let me present to you the accidental garden in my backyard (**image 11–21**). Elaborating on the play of light and shadow, I captured **image 11–22**, which can serve as a quiet background for many messages related to suburban living.

> 66 Learning the names of plants is important for stock photography. 99

Image 11–19 (above). KEYWORDS: cactus, cacti, jumping cholla, Cylindropuntia fulgida, hanging chain cholla, Sorona, Arizona

Image 11–20 (left). KEYWORDS: Equisetum fluviatile; garden; Horse Tail Reed; plant; swamp; swamp horsetail; water horsetail

Image 11–21. KEYWORDS: garage; garden; gardening; leaf; leaves; palm tree; shovel; tool; vine; Virginia Crawler; wall

Image 11–22. KEYWORDS: garage door; shadow; tree; sunset; sunrise; sawn; dusk; door knob

Image 11–23 (above). KEYWORDS: cloth; cut; design; pattern; quilt; quilting; sew; square; stitch

Image 11–24 (left). KEYWORDS: abandon; alone; chair; dog; leash; lonely; pet; pet carrier; pet owner; plant; restaurant; window

Hobbies

There are plenty of images of quilts, but there are many fewer images of quilts in the making. Having a wife who is keen on this hobby gave me the opportunity to create a shot like **image 11–23**. Remember: photographing what is around you is one of the essences of successful stock photography.

Pets

A not-so-happy-looking dog waiting for its dining owner can be a very utilitarian image for any topic about pets, and it was such a fun image to take for myself (**image 11–24**). Having fun is important for a stock photographer—especially because there is strong element of improvisation that comes with using a cell phone camera.

Index

Macrophotography

Insects, flowers, reptiles, amphibians—Dennis Quinn shows you how to get close and capture the beauty of these amazing, natural subjects. *$29.95 list, 7x10, 128p, 180 color images, ISBN 978-1-68203-076-9.*

101 Mistakes Photographers Should Never Make

Karen Dórame solves some of the problems that can result in poor images and failing photography businesses. *$37.95 list, 7x10, 128p, 340 color images, ISBN 978-1-68203-024-0.*

Shoot Cold

Joseph Classen explores the technical challenges and creative opportunities of winter photography, showing how to create bold, imaginative images. *$29.95 list, 7x10, 128p, 250 color images, ISBN 978-1-68203-068-4.*

Passport to Great Photography

Pack your bags! Robert Hull takes you around the world in this exploration of the skills that lead to standout photos. *$37.95 list, 7x10, 128p, 150 color images, ISBN 978-1-68203-060-8.*

Photographing Water

From delicate raindrops to crashing ocean waves, Heather Hummel shows you how to capture the beauty of water in all its many forms. *$37.95 list, 7x10, 128p, 280 color images, ISBN 978-1-68203-056-1.*

Also by Mark Chen . . .

Mastering Composition

Mark Chen explores a key step in the creation of every image: composition. Dive deep into this topic and gain total control over your images. *$37.95 list, 7x10, 128p, 128 color images, ISBN 978-1-60895-981-5.*

Mastering Exposure

Mark Chen explores a key step in the creation of every image: exposure. Dive deep into this topic and gain total control over your images. *$37.95 list, 8.5x11, 128p, 220 color images, ISBN 978-1-60895-957-0.*

Professional HDR Photography

Mark Chen helps you maximize detail with high dynamic range shooting and postproduction. *$27.95 list, 7.5x10, 128p, 250 images, ISBN 978-1-60895-637-1.*

Sikh Weddings

Gurm Sohal is your expert guide to photographing this growing sector of the wedding market. With these skills, you'll shoot with confidence! *$37.95 list, 7x10, 128p, 180 color images, ISBN 978-1-68203-036-3.*

Profit-Building for Pro Photographers

Jeff and Carolle Dachowski teach you marketing, pricing, sales, and branding—keys to a successful business. *$29.95 list, 7x10, 128p, 180 color images, ISBN 978-1-68203-040-0.*

Senior Style

Tim Schooler, well-known for his fashion-forward senior portraits, walks you through his approach to lighting, posing, and more. *$379.95 list, 7.5x10, 128p, 220 color images, ISBN 978-1-68203-020-2.*

Master Low Light Photography

Heather Hummel takes a dusk-to-dawn tour of photo techniques and shows how to make natural scenes come to life. *$37.95 list, 7x10, 128p, 180 color images, ISBN 978-1-68203-044-8.*

Black & White Artistry

Chuck Kimmerle shares some of his most evocative images and teaches you his creative approach to re-envisioning places and spaces. *$37.95 list, 7x10, 128p, 205 color images, ISBN 978-1-60895-965-5.*

The Complete Guide to Bird Photography

Jeffrey Rich shows you how to choose gear, get close, and capture the perfect moment. A must for bird lovers! *$29.95 list, 7x10, 128p, 294 color images, ISBN 978-1-68203-052-3.*

The iPhone Photographer

Michael Fagans shows how the iPhone's simple controls can push you toward greater creativity and artistic expression. *$27.95 list, 7.5x10, 128p, 300 images, ISBN 978-1-887-0.*

Relationship Portraits

Tim Walden shows you how he infuses his black & white portraits with narrative and emotion, for breath-taking results that will stand the test of time. *$34.95 list, 7x10, 128p, 180 color images, ISBN 978-1-68203-028-8.*

Magic Light and the Dynamic Landscape

Jeanine Leech helps you produce more engaging and beautiful images of the natural world. *$27.95 list, 7.5x10, 128p, 300 color images, ISBN 978-1-60895-729-3.*

Art with an iPhone

Kat Sloma's images reveal the iPhone as a sophisticated art-making tool. In this book, she walks you through her inventive approach. *$37.95 list, 8.5x11, 128p, 300 color images, ISBN 978-1-60895-977-8.*

The Mobile Photographer

Robert Fisher teaches you to use a mobile phone/tablet plus apps to capture incredible photos and create an efficient workflow. *$27.95 list, 7.5x10, 128p, 200 color images, ISBN 978-1-60895-823-8.*